IMAGES
of America

NEW YORK CITY
ZOOS AND AQUARIUM

D1202483

IMAGES

of America

NEW YORK CITY

ZOOS AND AQUARIUM

Joan Scheier

ARCADIA
PUBLISHING

Published by Arcadia Publishing
Charleston, South Carolina

Printed in the United States of America

Library of Congress Catalog Card Number: 2005932703

For all general information contact Arcadia Publishing at:
Telephone 843-853-2070
Fax 843-853-0044
E-mail sales@arcadiapublishing.com
For customer service and orders:
Toll-Free 1-888-313-2665

Visit us on the Internet at www.arcadiapublishing.com

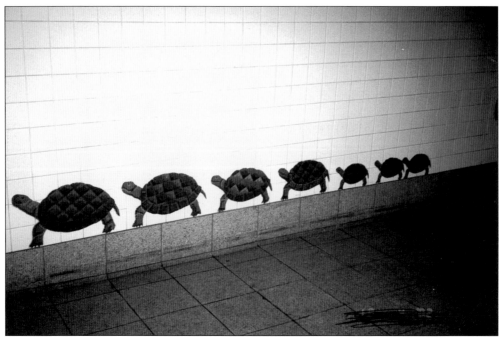

This mosaic of ducks, monkeys, birds, snails, and polar bears in the subway station of the R, N, and W trains give the visitors a preview of what they will see at the Central Park Zoo.

CONTENTS

ACKNOWLEDGMENTS

To the following, who shared their love of zoos and their history.

Special thanks to Steve Johnson, librarian at the Bronx Zoo, for all his help in finding the information needed to cover six facilities; to Judith Loeb, librarian at the Hillside Public Library, for her help with the research for this book; to Dr. Dan Wharton, director of the Central Park Zoo, for his enthusiasm and encouragement; and to Erin Vosgien and the staff of Arcadia Publishing for making this publication possible.

Thanks to Don Lewis, for sharing his knowledge of postcards; to Ferne Spieler and Emil Rossdeutscher for being so generous with their photographs; to Judith Wolfe for permission to use her photographs; to Victor Kun for making images fit to print. Thanks to Suzanne Boldac at the Bronx Zoo Archives, Lenora Gidland at the NYC Municipal Archives, and Amy Peck at the Prospect Park Archives, for finding unique photographs for this book.

Thanks to the staff and the keepers at all the facilities who were eager to share information and love of the animals in their care.

I want to give a special thanks to my son Allen, who started me on this journey, and a special thanks to Manny, Ida, Gus, Breezy, Seaweed, and Clarice who keep me enjoying my journey.

For more information, please visit http://www.newyorkcityzoos.com.

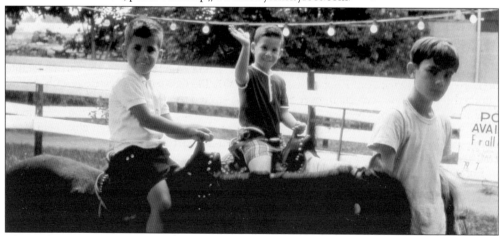

The author's sons, Allen (left) and Jerry Esses, are seen here riding horses at the children zoo in 1966.

One

THE CENTRAL PARK ZOO

The southeast corner of Central Park has a history of housing animals that is almost as old as the park itself. As early as the 1860s, animals could be found in and around the Arsenal building which is still located at Sixty-fourth Street and Fifth Avenue. "The Menagerie," as it was called, began when people started donating animals. It quickly grew into an attraction that drew people to the corner of the park. The Menagerie soon began to actively acquire animals and became a fixture for New Yorkers. In the 1930s, New York City Parks Commissioner Robert Moses formally built the Central Park Zoo on the site according to the best standards at the time and it was a popular destination for many years. By the 1980s, the world of zoos and zookeeping had progressed a great deal since the 1930s and the City of New York asked the New York Zoological Society to take over the running of the zoo, according to best industry practices. The Central Park Zoo reopened in 1988 as a NYZS (since renamed Wildlife Conservation Society) facility and is still going strong in the 21st century.

The zoo is organized into three climactic zones—tropical, temperate, and polar. Each of these zones allows visitors to have a year-round glimpse into the variety of wildlife that lives in those areas and exposes them to the fascinating variety of animal behavior. Through the use of naturalistic habitats one is immersed in a tropical rainforest, or an Antarctic penguin colony, or the foothills of the Himalayas, all in the heart of New York City. However connections to the past remain, in the form of original brick friezes, weathervanes, paving stones, and statues. In addition, two buildings from the zoo of the 1930s remain, the former monkey house is now the Hecksher Zoo School and the former bird house is now the Central Park Zootique gift shop. An addition to the zoo was made in 1998 with the opening of the Tisch Children's Zoo, which includes a walk-through aviary and a petting zoo featuring domestic animals.

The world has changed a great deal in the nearly 150 years since animals first were exhibited in Central Park. Wildlife and wild places are in increasing danger due to a variety of threats. WCS and the Central Park Zoo hope to educate people of all ages about the natural world and inspire them to protect it. In the heart of one of the densest urban landscapes in the world, we allow people to stop, take a breath, and reconnect to nature. We hope you will too.

—John Rowden, curator of animals, Central Park Zoo

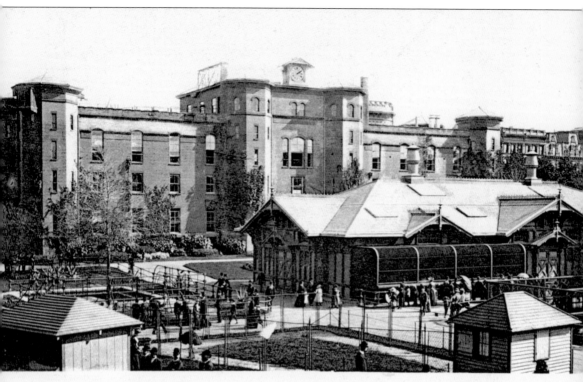

Menagerie, Central Park, New York

The Arsenal, the brick building on Fifth Avenue and Sixty-fourth Street, is older than the zoo itself. In 1864, an enclosed space was set aside near the Arsenal to give the animals that were donated by private citizens, hunters, circuses, and carnivals a permanent home. As the animal collection grew, it became necessary to construct buildings and enclosures. (Joan Scheier.)

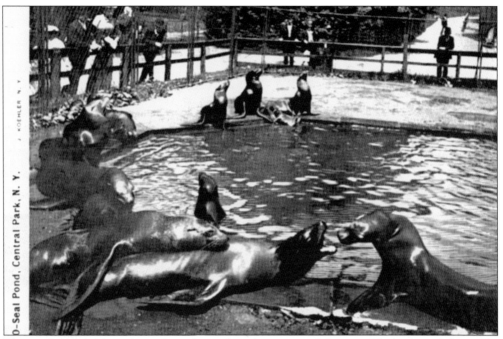

The sea lion pool has always been located at the center of the zoo. This postcard shows the combination of wood and wire fencing that was used to keep the visitors out and sea lions in. You could always find your way to the center of the zoo by following the sounds of barking sea lions. (Joan Scheier.)

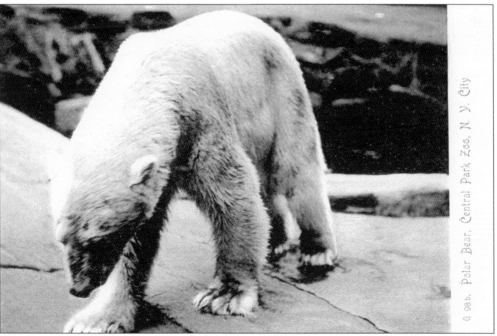

The polar bears and sea lions are two species that have always been at the Central Park Zoo. It was not unusual for zoos to obtain animals from others zoos, private donations, the circus, and animal brokers. Germany gave the Central Park Zoo a gift of a polar bear in the 1880s. (Joan Scheier.)

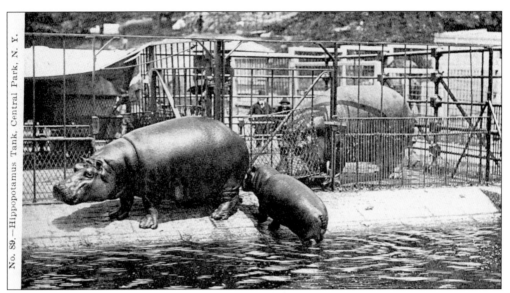

No. 89.—Hippopotamus Tank, Central Park, N. Y.

Rosie the hippopotamus was reported to have had four babies while at the Menagerie. The visitors to the menagerie had a chance to see animals that they had only heard about or seen pictures of in books. Every effort was made to provide the animals with the type of environment they would enjoy in the wild. In this case, it would be a water pool to submerge in and keep cool. (Joan Scheier.)

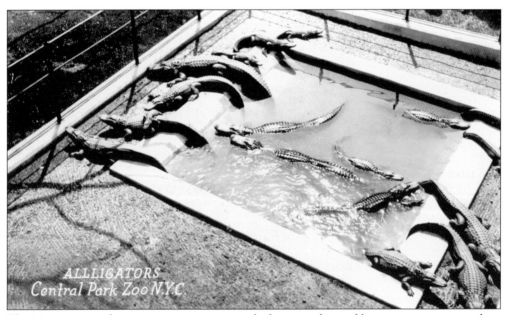

ALLLIGATORS
Central Park Zoo N.Y.C.

The Menagerie was home to many exotic animals that were donated by citizens or were trophies from hunting expeditions. The enclosure used railings and mesh to ensure the alligators did not escape. The Menagerie was known as a "Postage Stamp Collection," animals placed next to each other as their cages were built. (Joan Scheier.)

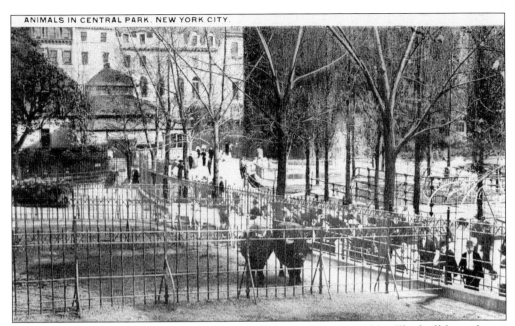

This postcard view was just before the closing of the Menagerie in 1934. The buffalo enclosure was just steps away from Fifth Avenue. The Menagerie needed repairs and Robert Moses felt New York City needed a zoo of its own. It took nine months to build the new zoo, sometimes called "the Robert Moses Zoo," or "the Picture Book Zoo," but always known as the Central Park Zoo. (Joan Scheier.)

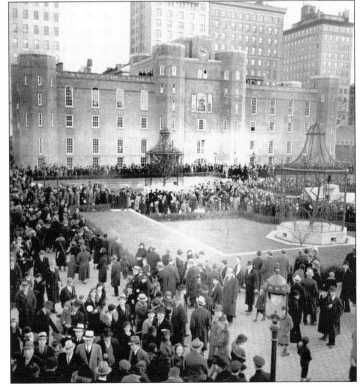

The zoo reopened on December 2, 1934, and was a hit from the start. The zoo contained a comfort station and a restaurant overlooking the sea lion pool. The zoo would contain many wild animals including three types of bears, elephants, gorillas, tigers, birds, monkeys, and hoofed animals. (Alajos L. Schuszler, NYC Parks Archives.)

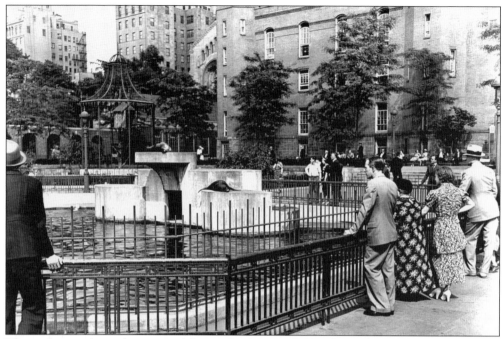

The sea lion pool is at the center of the zoo. In the zoo of 1934, the sea lions reclined on concrete platforms. The keepers would feed them from the center railings that ran around the enclosure. The Arsenal, the anchor of the zoo, is visible as are the buildings along Fifth Avenue. Four ornate bird cages surrounded the sea lion pool and were home to birds, small animals, or flowers depending on the weather. (NYC Municipal Archives, WPA records.)

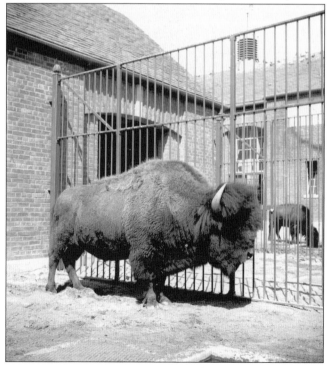

Hoofed animals lived and bred successfully at the Central Park Zoo. The largest and most famous was the American bison, Black Diamond. The pose of this buffalo in 1936 may look familiar as it is the image that appears on the nickel known today as the Buffalo Nickel. (Alajos L. Schuszler, NYC Parks Photograph Archives.)

Eight concrete eagles were presented to the Central Park Zoo in 1937. They came from the First Avenue Bridge in Brooklyn when it was demolished to make way for the Gowanus Canal. When the zoo was renovated in 1988, the eight concrete eagles returned to their original posts in the zoo. It is still a favorite spot to stop and take a souvenir photograph of a trip to the zoo. (Joan Scheier; http://www.cpzbook.com.)

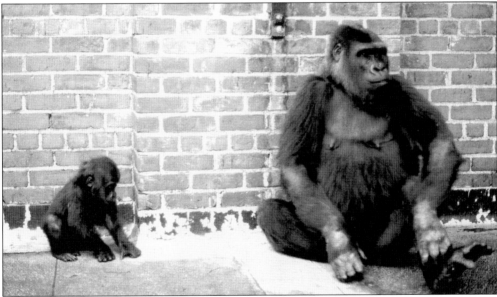

Patty Cake, a baby gorilla, pictured here with her mother Lulu, was born September 3, 1972. This was a rare event in the zoo community; few were born and raised in captivity. Patty Cake came as a surprise when Lulu held up a small ball of black fur for her keeper to see. Just months after her birth, her arm was accidentally broken when both parents reached for her. She was brought to the Bronx Zoo to heal after her arm was set. Her parents were lost without her. When she was returned to her parents she was greeted with cries of joy. Patty Cake now resides in the Congo exhibit at the Bronx Zoo and has had nine children. (Dr. Ronald D. Nadler, Yerkes Regional Primate Center, Emory University, Atlanta, Georgia.)

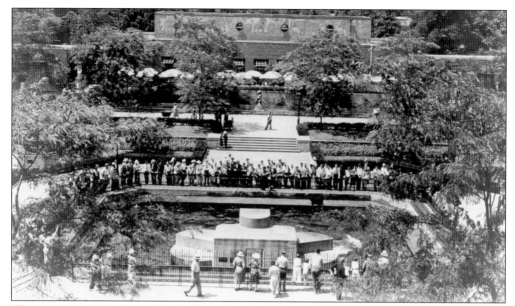

This is a view of the Central Park Zoo taken from the roof of the Arsenal. In the center is the sea lion pool. In the background is Kelly's Restaurant Terrace with its deck of colorful umbrellas. Atop the restaurant can be seen a large hand-painted mural showing the animals that could be seen in the zoo. The zoo is surrounded by tall buildings on three sides, reminding the visitors that they are in the center of one of the largest cities in the world. (NYC Municipal Archives, WPA records.)

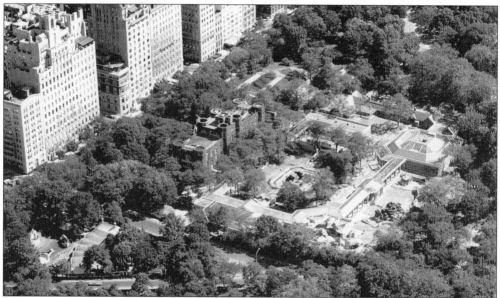

When the zoo reopened in 1988, it was operated by the Wildlife Conservation Society. Sterile cages with bars were removed as were most of the large animals except for sea lions and polar bears which had been at the zoo since the 1860s. The zoo occupied the same location as the Menagerie and the Robert Moses Zoo, just steps off Fifth Avenue. At the left can be seen the children zoo that was built in 1961 and was replaced with a petting zoo with the emphasis on education in 1997. (Private collection.)

When the Central Park Zoo reopened for the third time, the sea lions were once again front and center. The sea lions are hand fed three times a day and taught behaviors that act as enrichment and keep them mentally stimulated. The pool is surrounded by clear glass and steps surrounding the enclosure enable visitors to watch the sea lions as they swim underwater. (Celia Ackerman.)

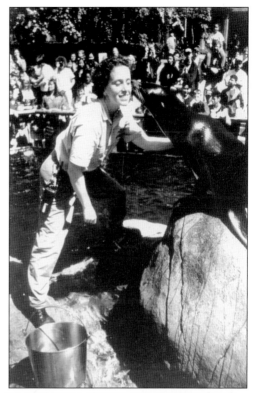

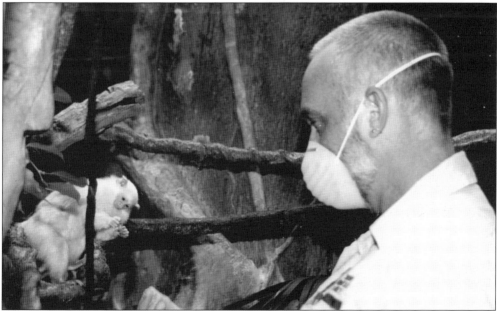

All animals large and small receive hands-on enrichment and behavioral training from the keepers. Here is a marmoset in the rainforest examining a meal worm he received as an enrichment reward. The close contact with the keepers allows them to keep an eye on the animals' health and behavior. Paper bags filled with fruit are put into the enclosure for the monkeys to enjoy tearing apart. This will simulate natural foraging behavior. (Ferne Spieler.)

The Central Park Zoo is divided into three zones: temperate, polar, and rainforest. The polar zone is home to two polar bears, Gus and Ida. There are viewing areas on three levels. It is not unusual to see Ida watching the visitors as they watch her. Natural behaviors are encouraged, as zookeepers feed the bears live trout and hide food in the enclosure so that the bears have to find their meal as they would in the wild. (Ferne Spieler.)

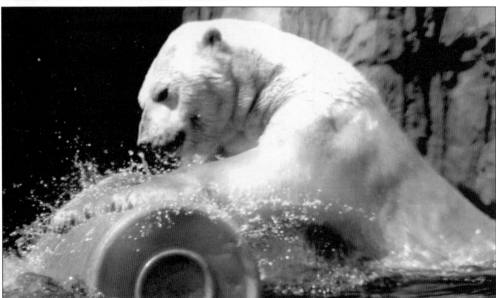

Gus, one of the two polar bears at the zoo, is playing with a small empty blue drum. Since the drums float, the bears like to try and pounce on the top and hold onto the drums or any large object that floats. The bears like to try to stand on top of the drums in the water with all four feet, which they have become skilled at doing. The drums are good for displaying a pouncing behavior on land, which mimics the natural behavior of pouncing on the roof of a seal den after spotting the air holes made by the seals. (Ferne Spieler.)

The Central Park Zoo is part of the Survival Species Program (SSP) that guides the zoo with the select breeding programs. There have been many successful births in all three of the zoo's zones. In 2004, two red panda twin girls were born in the temperate zone at the Central Park Zoo. Here is the keeper holding the new cubs. Keepers always wear protective masks and gloves when interacting with the youngsters to protect the cubs from germs that can be passed to them by humans. (CPZ Animal Department.)

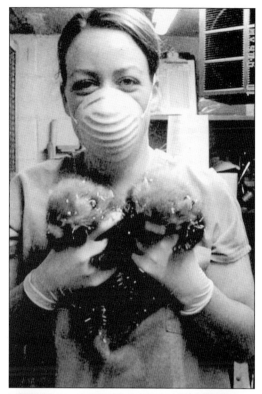

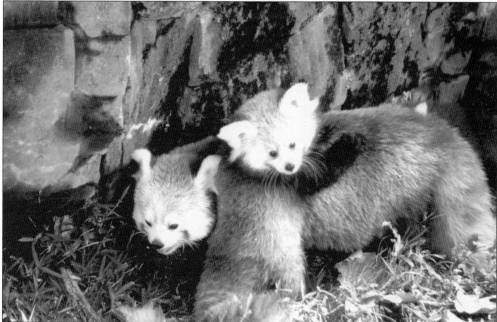

The red panda twin girls born at the zoo are named Rose and Scarlet. They spend time exploring the enclosure for healthy treats the keepers have put out for them. The twins spend time sleeping curled up on a branch of a tree. They are about the size of a house cat and more closely related to raccoons than giant pandas. (Ferne Spieler.)

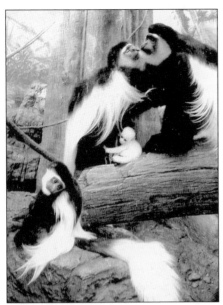

The rainforest zone is home to primates, birds, and reptiles that would be found in the rainforests of the world. Black and white Colobus monkeys occupy a habitat that contains rocks and branches for napping and climbing. The babies are white at birth, but take on the coloration of their parents as they mature. The mural painted on the background wall simulates a view in a rain forest. The monkeys are easily seen through a large glass panel that covers the entire enclosure from top to bottom. Natural light is let in through a roof skylight. The temperature ranges from 72 to 85 degrees. (Judith Wolfe; http://www.judithwolfe.com.)

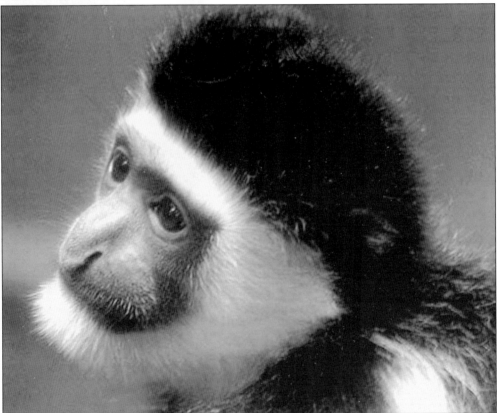

This is a two-year-old female black and white Colobus monkey born at the Central Park Zoo. She enjoys flying through the air and waking up the adults to play with her. She will also come to the window and check out the visitors. They receive behavior training daily and are rewarded with their favorite fruits. (Judith Wolfe.)

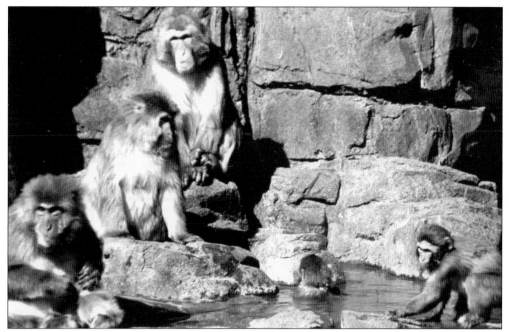

Snow monkeys, also known as Japanese macques, are in the temperate zone. There are four adults and five juveniles. The enclosure occupies the space that was once Kelley's Restaurant. There are no bars, just water and glass on one side and rocky slopes on the other three sides. Here are three adults and two youngsters enjoying the hot tub. (Ferne Spieler.)

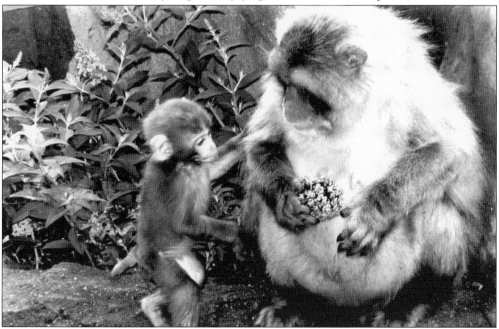

This is a three-month-old female snow monkey with her mother. The juveniles show an interest to almost anything that the older members of the troupe are doing. The face will darken as she gets older and thick fur will grow in over her ears. The youngsters enjoy playing hide and seek, grooming each other, jumping into the hot tub, and taking a group nap. (Ferne Spieler.)

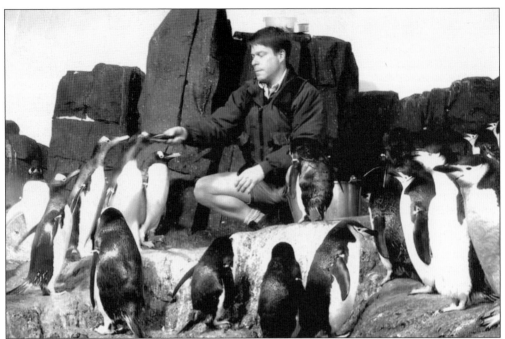

The penguins at the Central Park Zoo live in a temperature-controlled environment. The temperature of the water is 42 degrees and the air is 34 degrees. This is a very successful breeding colony of Gentoo and Chinstrap penguins that can be found in the Antarctic. The penguins are hand-fed twice a day. This is a two-keeper effort. One keeper will feed the penguins while the other keeper keeps track of how much each penguin is eating. This allows the keepers to have close contact with the birds and to spot any signs of illness. (Ferne Spieler.)

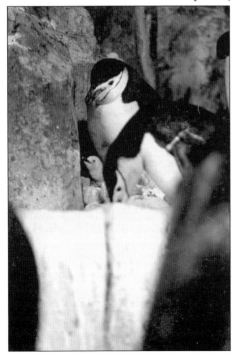

The Edge of the Icepack is the name of the penguin colony that is located in the polar zone at the Central Park Zoo. The glass allows visitors to view the penguins swimming and diving underwater. In the spring the keepers place rocks on the bottom of the enclosure for the penguins to use to build their nests. A Chinstrap penguin chick has fuzzy grey feathers, which are not water proof. Both parents tend to the nest and feed the chick once it has hatched. In the same building is a colony of tufted puffins. (Ferne Spieler; http://www.earthcam.com/usa/newyork/cpzoo.)

A pair of Victoria Crowned pigeons lives in the rainforest habitat at the zoo. They walk around freely and often can be seen perched on the railings or at their food tray, which is placed where visitors can watch them. They have successfully hatched two chicks. The chicks are born with no lace head crest. Breeding these birds can be difficult in captivity. The success of this program is an indication of how the staff has created a natural habitat, allowing the birds to feel at home enough to breed. (Judith Wolfe.)

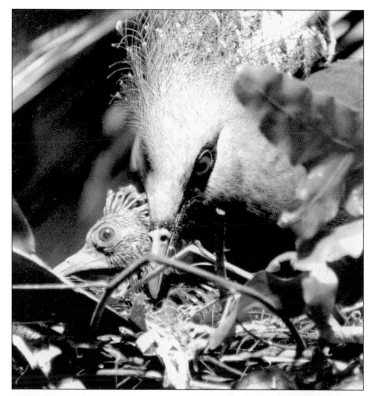

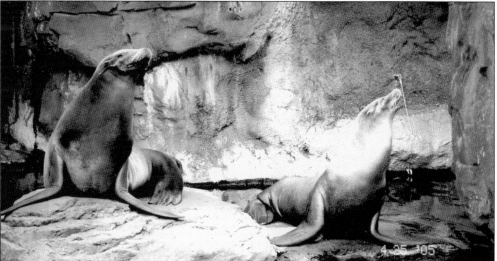

Advances in veterinary care have enabled many animals to live long and healthy lives. Breezy and Seaweed are two senior sea lions that live in a separate enclosure in the temperate zone along with a harbor seal and an Arctic fox. Breezy is the oldest sea lion in any zoo at 35-plus years old. Seaweed is 30 years old. Both of these seniors started at the Long Island Game Farm. They were moved to the New York Aquarium at Coney Island and then to the Central Park Zoo when it reopened in 1988. The enclosure also includes a large beach, a waterfall, and a large rock in the center, which they can share. They are hand fed three times a day. This is an outstanding example of zoos including senior animals in their exhibits. (Animal Department.)

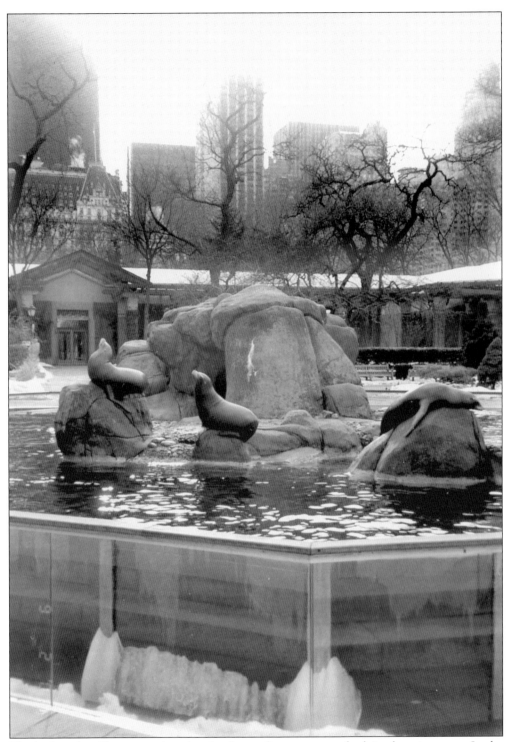

The high rocks offer a natural setting for the sea lions to nap or bask in the winter sun. In the background are the buildings of Central Park South including the Plaza Hotel and the Essex House. All the zoos in New York City are open 365 days a year. (Ferne Spieler.)

Two

THE BRONX ZOO

In these photographs of the Bronx Zoo, one finds images of the vanished, the quirky, and the familiar.

Vanished are the barred bear dens, replaced by moated exhibits. Vanished also are the cages of the 1903 lion house. In 1941, the lions moved to the African plains exhibit. In 1985, the snow leopards decamped for the Himalayan highlands. About 2007, the lion house will be reborn as an exhibit immersing visitors in the environment and animals of Madagascar.

The Rocking Stone Restaurant, gone since 1941, is now occupied by the World of Darkness.

For more than half a century, the Bronx Zoo's bison herd roamed a field not far from the Rocking Stone, near the south end of the zoo. Since 1971, the bison have occupied a range adjacent to the Paul Rainey Memorial Gates, at the north end of the zoo.

Grace Rainey Rogers, the sister of Paul Rainey, commissioned sculptor Paul Manship to create the Rainey Gates in memory of her brother, who met an untimely death at sea on 1923. The gates, erected in 1934, are shown here, in this chapter, in postcards and drawings. New York City declared the Rainey Gates a landmark in 1967.

Another example of the Bronx Zoo's animal sculpture collection is Senor Lopez, the jaguar created by Anna Hyatt Huntington. The sculpture was presented to the zoo in 1937. The real Senor Lopez lived at the zoo from 1902 to 1914.

Not completely vanished is the architecture. Zookeepers no longer walk elephants along public paths of the zoo, as depicted in one early photograph. Indeed, zookeepers no longer have this type of unprotected contact with elephants anywhere in the Bronx Zoo, whether in public or behind the scenes.

The quirky past persists in images of the chimpanzee and the keeper, the flag-waving chimpanzee, the force-feeding of a giant snake which has gone off its food.

Familiar to all now is the name the Bronx Zoo, shown in a postcard from the 1950s. Some readers may be surprised to learn that the zoo's management remained hostile to this name for more than 40 years after the opening of the zoo. The use of the Bronx Zoo name after 1940 was another sign that the world view of the original zoo was a thing of the past.

Change of course continues today. The ghost architecture of the zoo now includes such long familiar sites as the 1950 Great Apes House, demolished after the opening of Congo Gorilla Forest in 1999. The Butterfly Garden now occupies the site of the former Great Apes House.

In the 21st century landscape of the Bronx Zoo, one finds 265 acres of modern zoo exhibits and animal enrichment. In these zoo images from the near and distant past, one finds views of what has gone before.

To obtain perspective, take a day to walk around the Bronx Zoo. Bring your copy of this book. Compare. Discuss!

—Steve Johnson, Manager, Bronx Zoo Library, August 9, 2005

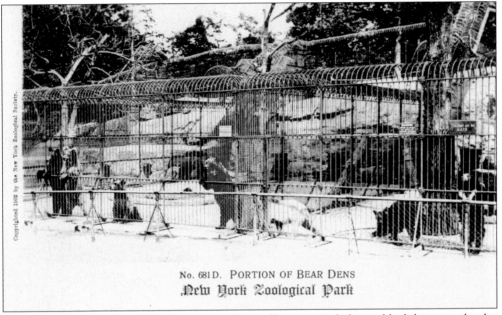

No. 681 D. PORTION OF BEAR DENS
𝕹𝖊𝖜 𝖄𝖔𝖗𝖐 𝖅𝖔𝖔𝖑𝖔𝖌𝖎𝖈𝖆𝖑 𝖕𝖆𝖗𝖐

When the zoo opened in 1899 they had in their collection grizzly bears, black bears, and polar bears. The dens were set against the huge rocks that were natural to the park. This is an example of an early cage that was common at the beginning of the 20th century. (Joan Scheier.)

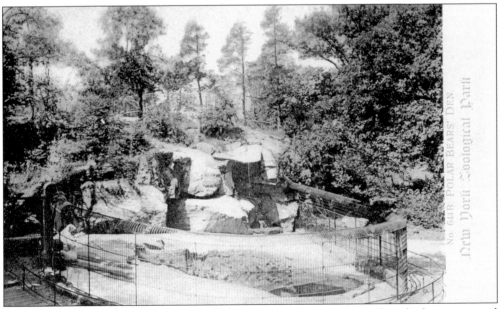

The early steel-caged bear dens built in 1900 were set against massive rocks, which were natural in the Bronx Park. The four cages were used for grizzly bears, black bears, polar bears, and brown bears. The species were separated by iron bars. Animals were removed from this type of caging in the early 1960s and moved into a new habitat that opened in 1968. (Joan Scheier.)

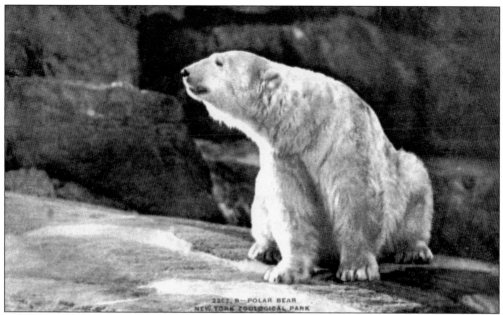

Polar bears have always been a popular destination for visitors to the zoo. This postcard from 1906 shows the polar bear in an outdoor enclosure sunning on the rocks. Today the polar bears have both an indoor and outdoor enclosure. (Joan Scheier.)

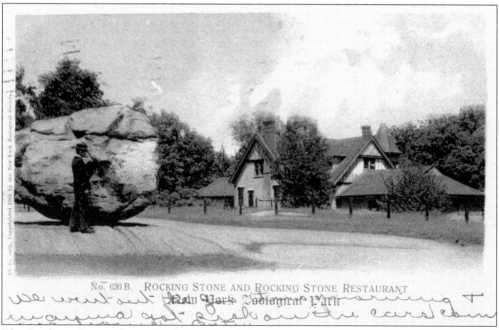

The Rocking Stone, shown in this postcard from 1905, is a 40-ton boulder of pink granite. Seventy pounds of pressure applied at certain points on its surface caused it to rock about an inch. The Rocking Stone Restaurant is seen in the background. The restaurant closed and was demolished in the 1940s. The World of Darkness opened in 1959 on the site, and the boulder was moved slightly so it could no longer be rocked. (Joan Scheier.)

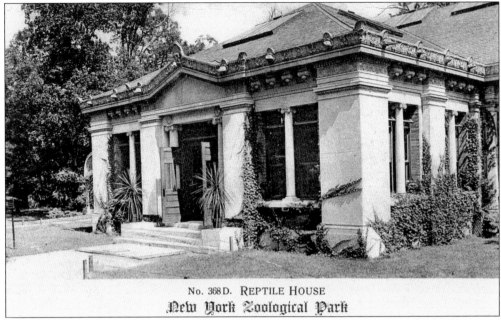

No. 368 D. REPTILE HOUSE
New York Zoological Park

The reptile house, the oldest building in the Bronx Zoo, opened in 1899. The building was planned by William Hornaday, based on the London Zoo's reptile house designed by Heins and LaFarge. It was called the most beautiful reptile house in the world. This was one of the first major buildings to be constructed. According to attendance records, it was the most popular exhibit in the zoo. The design included colored tiles and varied cage backgrounds that portrayed natural settings. Soft music was added to soothe those timid about snakes. The interior was renovated and the building reopened in 1954. (Joan Scheier.)

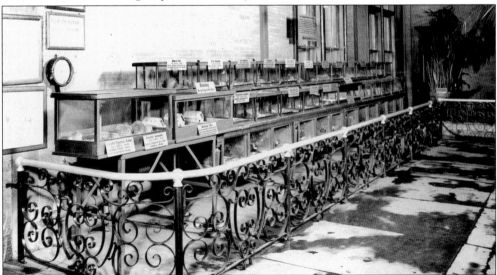

A collection of small reptiles was shown in cages behind an ornate gate. The signs indicated the species and where they would be found in the wild. The collection was originally done by donations. The reptile house as had several renovations with the emphasis on education, natural exhibits, and a reptile nursery. The building was renovated for a third time in 1969, and includes natural environments for swamps, deserts, rainforests, and ponds. (© WCS.)

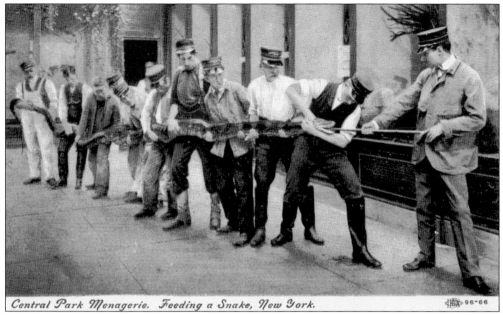

Central Park Menagerie. Feeding a Snake, New York. 96-66

This is the reptile house at the beginning of the 20th century. Pictured is a python that could grow up to 20 feet. Force-feeding of the snake was done only on snakes that were off their feed. Trees and rocks in the exhibit allowed the snakes to have a more natural environment that would allow them to wrap themselves around branches as they would in the wild. This postcard is mismarked. Although the card says Central Park Menagerie, it is the Bronx Zoo. (Joan Scheier.)

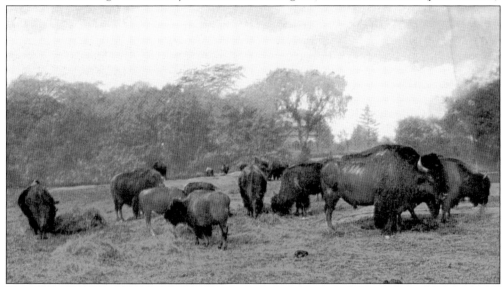

The Bronx Zoo has played an important part in the recovery of the American bison, which had been drastically reduced from 60 million to less than 1,700 worldwide by 1905. The original buffalo herd was established in 1899. This herd supplied animals to various refuges and preserves with the purpose of bringing back the buffalo from the edge of extinction. The American Bison Society was established in 1905. William Hornaday of the New York Zoological Society was president and Theodore Roosevelt was an honorary president. The society was generally credited with saving the bison from extinction in the United States. (Joan Scheier.)

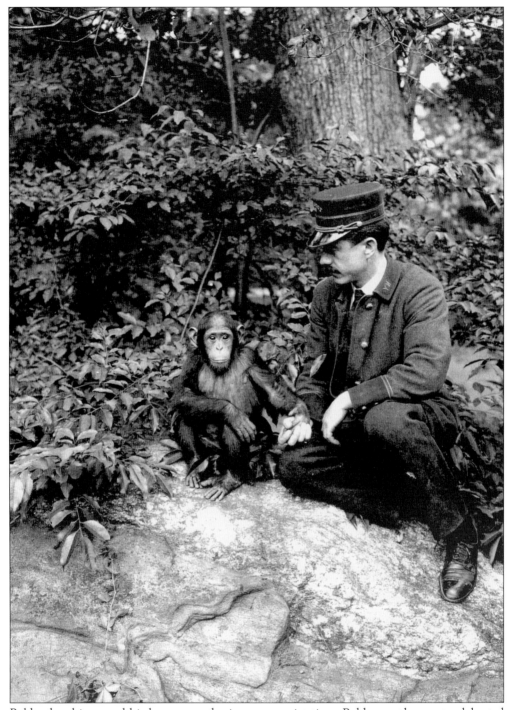

Baldy, the chimp, and his keeper are sharing some quiet time. Baldy was the most celebrated chimp in the animal collection. He often appeared in costumes and sat at a table to eat with a knife and fork. (© WCS.)

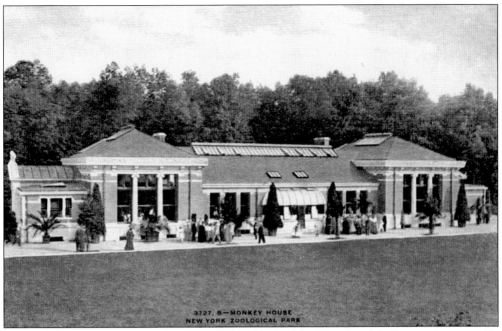

This building planned by William Hornaday, designed by Heins and LaFarge, was originally called the Primate House when it opened in 1901. The decorative friezes and sculptures of various primates are by A. Phimister Proctor, whose artwork can be seen on other buildings in the zoo. The Primate House closed in 1950, after the opening of the Great Apes House. It reopened in 1959, and is now called the Monkey House. (Joan Scheier.)

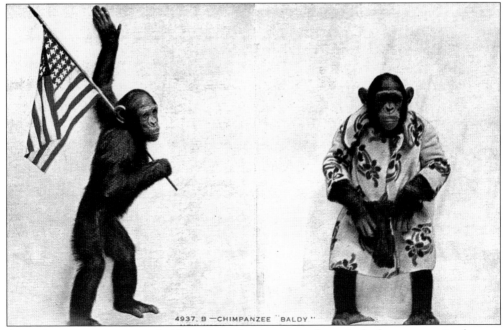

Animals in costumes were a holdover from the circuses and carnivals that many animals came from. Baldy had many costumes including patriotic ones. The keepers would often go into the cages to give them attention. (Joan Scheier.)

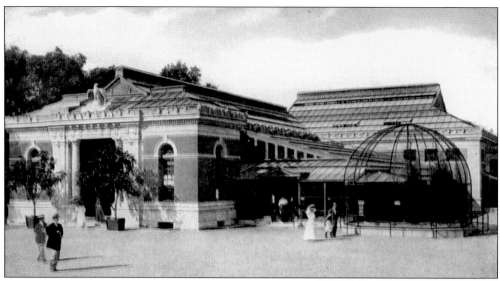

The large bird house was opened on July 4, 1905. Inside, both halls and the Glass Court were completely sky-lit with panels of clouded glass that could be opened for ventilation. The main hall included a central flying cage. Palms in tubs and hanging baskets of flowering vines combined flowers with brightly colored songbirds. There were 19 outside cages with a domed aviary. The large bird house closed in 1972, when the World of Birds opened. The building re-opened as administration offices in 1992. (Joan Scheier.)

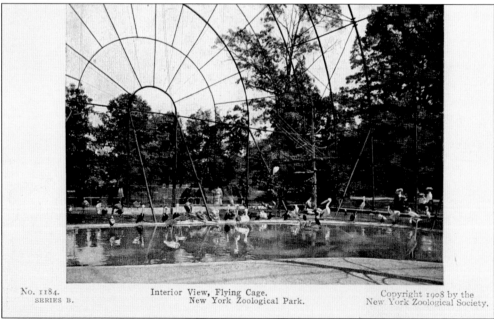

No. 1184. Interior View, Flying Cage. Copyright 1908 by the
SERIES B. New York Zoological Park. New York Zoological Society.

The Great Flying Cage was designed as a walk-through exhibition that opened in 1900. It housed over 100 water birds of 25 species. This postcard, marked 1910, shows the interior that contained trees, plant life, and running water. It opened to the outside and many exotic birds, such as pelicans and flamingos, were on display there. The cage was 150 feet long, 75 feet wide, and 50 feet high, and it was designed by Heins and LaFarge. The Great Flying Cage was completely replaced in 1930. The current aviary is the fourth on the site. (Joan Scheier.)

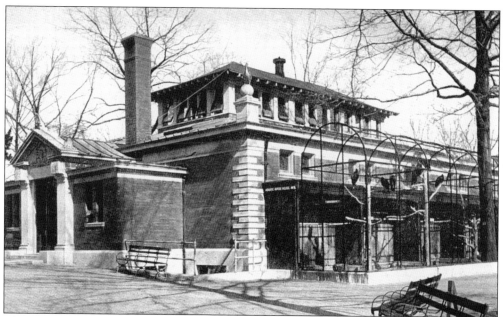

The aquatic bird house was one of two buildings completed when the zoo opened on November 8, 1899. Opening ceremonies were held at a platform in front of the entrance. The cost of the building was $26,000. In the center could be seen flamingos, ducks, and other water birds in a natural water exhibit. The building was admired for its spaciousness. Birds of prey and other birds of interest were exhibited in outside cages. In 1964, the building was demolished and a new building twice its size took its place. (Joan Scheier.)

This is a rustic pavilion that for many years served as a refreshment booth. The thatched roof follows the theme of a safari drive. This would only have been opened during the summer months. (© WCS.)

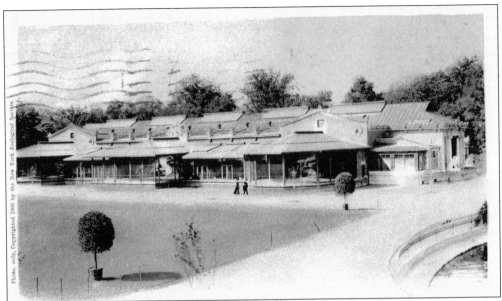

The lion house opened in January 1903 and originally showed Barbary lions that were donated by Nelson Rockefeller and Andrew Carnegie. Other donated animals included Nubian lions, Siberian and Bengal tigers, jaguars, snow leopards and black leopards. The lion house, designed by Heins and La Farge, is the longest and most ornate building. This building was based on the lion house at the Zoological Gardens in London, England. The façade facing the court had raised outdoor cages, the interior contained 12 raised cages. (Joan Scheier.)

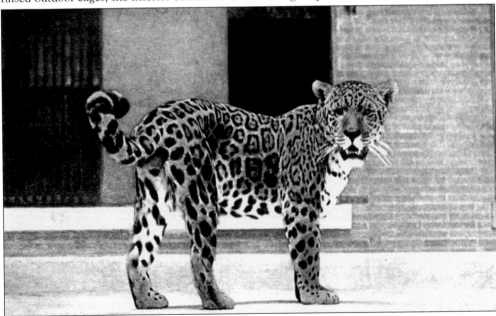

This is the famous jaguar, Senor Lopez, on a postcard dated 1906. He had the distinction of being the first inhabitant of the lion house. He had a playful disposition and was willing to play with anyone who came near his cage. He had a trick of rolling on his back, with his paws in the air, just like a good-natured house cat. Senor Lopez resides in the Bronx Zoo in the form of two marble statues done by Anne Vaughn Hyatt Huntington. (Joan Scheier.)

34

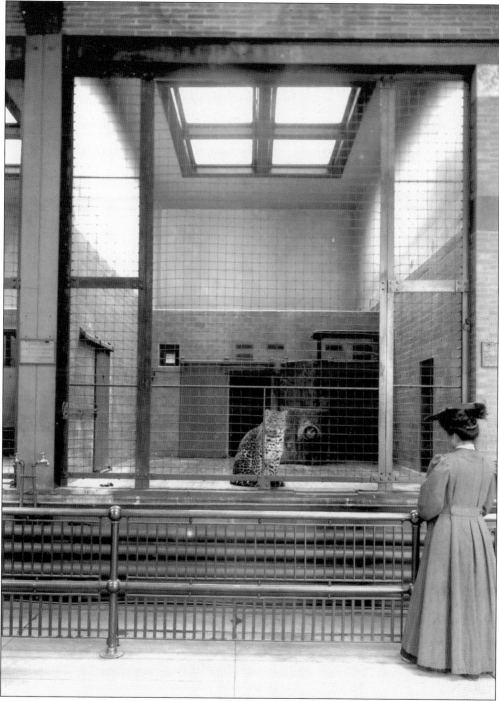

The lion house, in 1905, was considered an enlightened zoo design of its time. The elements of the design emphasized cleanliness and light; cages marked with the name of the species and where it could be found in the wild. The zoo-goers' desire for an uninterrupted view of the exhibits was also a prime consideration. This is an excellent example of how a zoo exhibit would look over 100 years ago. (© WCS.)

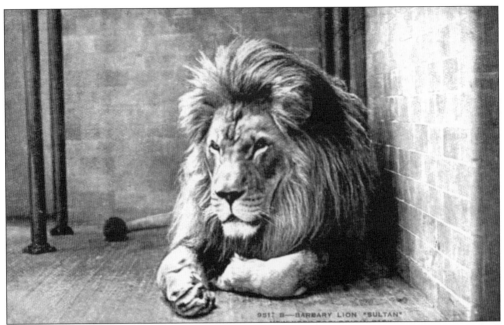

The Barbary lion, Sultan, was the first lion to be put on exhibit in the lion house. The main hall has a high sky lighted roof. Cages were located both inside and outside the building. The Barbary lion is more compact and heavy in build than other lions. It has a short broad muzzle with a wide face, large round amber eyes, and a thick mane that extends down the chest and around the shoulders. It gives the animal the appearance of being 50 percent mane. (Joan Scheier.)

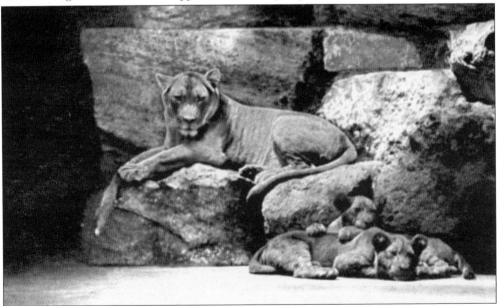

The lion house provided rocks for the lions to recline and sleep on. It was always the aim of the New York Zoological Society to provide as much natural habitat as it could. If the animals are comfortable in the environment, they will successfully breed. Here is a Barbary lioness with her two cubs. In the early days of the society, many animals were donated by hunters as well as by private and public donations. (Joan Scheier.)

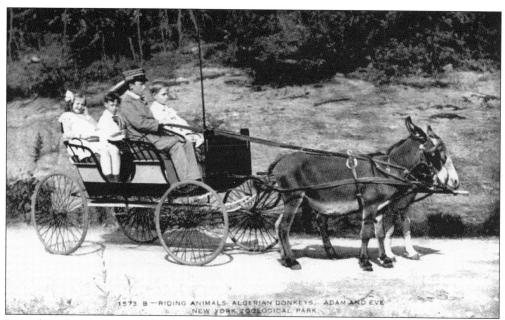

Part of visiting the Bronx Zoo would be riding on a Welch Pony or being in a cart being pulled by Algerian donkeys named Adam and Eve. There would be designated paths in the park and they would be guided by staff in uniforms. Today the Bronx Zoo continues the tradition with camel rides and a monorail and skyfari that give larger views of the zoo. (Joan Scheier.)

"Greetings from the Bronx Zoo" is a postcard that shows, inside each of the letters, the animals that would be found in the zoo. The animals shown include polar bears, elk, elephants, and gorillas. Photographic postcards that spelled out the name of an attraction were very popular in the 1950s. (Joan Scheier.)

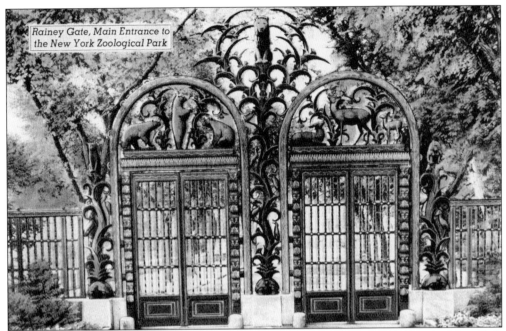

Rainey Gate, Main Entrance to the New York Zoological Park

The sculpted gateway to the Bronx Zoo, off Fordham Road, was presented to the New York Zoological Society in 1934 by Grace Rainey Rogers as a tribute to her brother, Paul J. Rainey, member and explorer who contributed to the society's collection of animals. The gate was sculpted by Paul Manship and was 36 feet high and 42 feet wide. The tree of life and 22 animals are depicted in the Paul Rainey Memorial Gate. The animals include Sultan the lion, in the center keeping an eye on all who enter, Buster the Galapagos tortoise, (in triplicate) Jimmy the shoebill stork, and three bears. Other animals shown are ibis, crane, cougar, baboon, penguin, heron, hornbill, owl, flamingo, and pelican. (Don Lewis.)

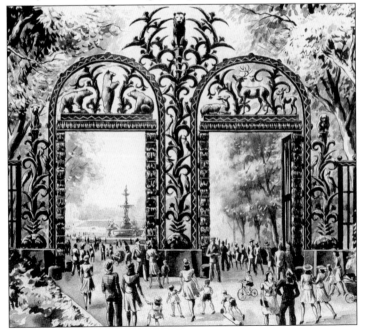

This drawing depicts the Rainey Memorial Gate done in 1945. In the foreground can be seen a sailor in World War II uniform and carriages and scooters that would have been in use at that time. The Rockefeller Fountain can be seen in the background. (Private collection.)

38

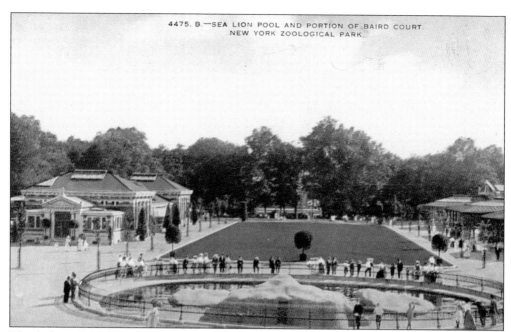

The kidney-shaped sea lion pool opened in 1906 and was designed with artificial rocks for climbing and shelter. The city paid a little more than $4,000 for the original pool. The sea lions' loud barking was as welcome of a sound then as it is today. All of the New York City zoos operated by the Wildlife Conservation Society have sea lions. (Joan Scheier.)

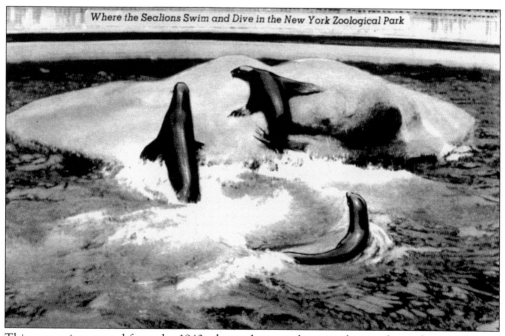

Where the Sealions Swim and Dive in the New York Zoological Park

This souvenir postcard from the 1940s shows three sea lions in their rocky enclosure. The sea lion pool reopened in 1981, doubling the size of the exhibit and adding a larger California rocky beach environment. (Joan Scheier.)

In 1907, a competition among sculptors for the decoration of the new elephant house ended in a dead heat between Alexander Phimister Proctor and Charles Robert Knight. Proctor was assigned to do the sculpture on the south side, an Indian elephant shown above. Knight was assigned the sculpture of an Asian elephant that appears on the north side of the building. The Bronx Zoo was home to many artists whose work can be seen on the outside of buildings as friezes, statues, and fountains. Naturalistic murals by talented artists can be found on the walls inside the exhibits. (© WCS.)

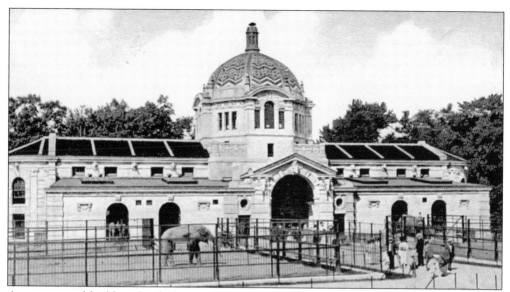

A monumental building for elephants, rhinoceroses, and hippopotamuses opened November 20, 1908. Kings built menageries; the elephant house was designed to look like a palace. There were eight large cages on the inside while the elephants occupied both the outside and inside yards. The structure was modeled on the Palais des Hippopotamus in Antwerp, Belgium. William Hornaday, the first director of the zoo, liked the structures that appeared in large European zoos. The building was renovated and reopened in 1989 as the Keith W. Johnson Zoo Center with many changing educational exhibits. Elephants are now displayed at the Wild Asia exhibit. (Joan Scheier.)

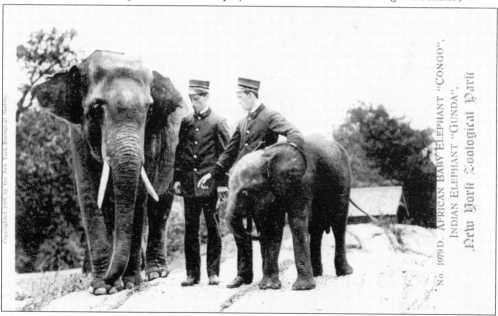

The zoo acquired Gunda, its first Indian elephant from Col. Oliver H. Payne for $2,350, and Congo, the first African elephant, was bought for $2,500 in 1905. It was not unusual to purchase animals from brokers or trade with other zoos and circuses. These large mammals were a learning experience for the staff in how to handle large animals. They were moved into the new elephant house in 1908. (Joan Scheier.)

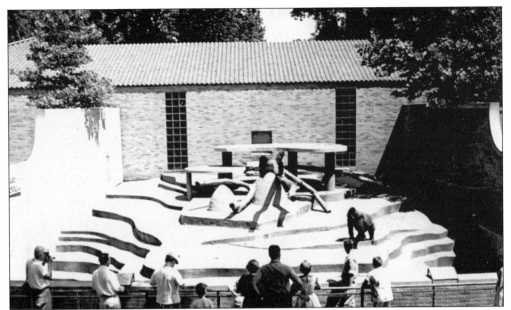

The Great Apes House opened in 1950 and had five large out of doors enclosures for gorillas, orangutans, and chimpanzees. This yard was the summer home for lowland gorillas. This is an example of how zoo designs evolved from small, bare-caged exhibits to outdoor areas with no bars, using moats to separate the visitors from the animals. Glass fronts and some landscaping were introduced for the indoor exhibits. Climate control mechanisms were one more step in improving the environment of the zoo occupants. (Joan Scheier.)

Andy, a baby orangutan, opened the Great Apes House in October 1950. Pres. Fairfield Osborn held Andy within reach of a bunch of grapes that joined two ends of a ribbon across the door. Andy picked a grape, the ribbons parted, and the building was proclaimed opened. (Joan Scheier.)

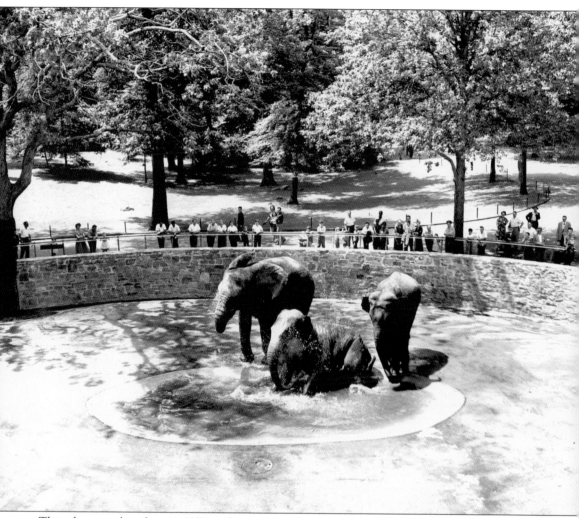

This photograph, taken in 1952, indicates how the zoos of New York City were moving from cages to open areas with moats to keep the distance between the elephants and the public. Elephants were walked by keepers. Their enclosure included water and soft sand or grass to give the animals a more comfortable living environment. (© WCS.)

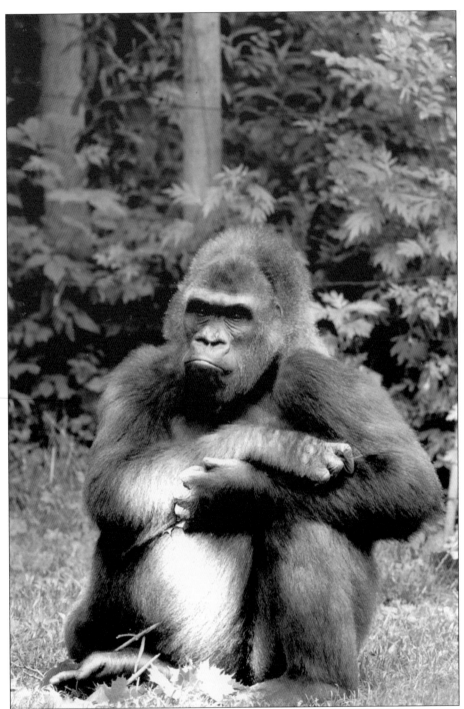

Patty Cake, a gorilla, was born at the Central Park Zoo on September 3, 1972. She now resides at the newest gorilla habitat Congo Gorilla Forest at the Bronx Zoo. Patty Cake has had nine offspring, her latest was a little girl Nyasha, born in February 2002. The breeding program at the Bronx Zoo, controlled by the SSP (Survival Species Plan) allows breeding with specific pairs to make sure that those gorillas being born will add new genes to zoos all over the world. (© WCS.)

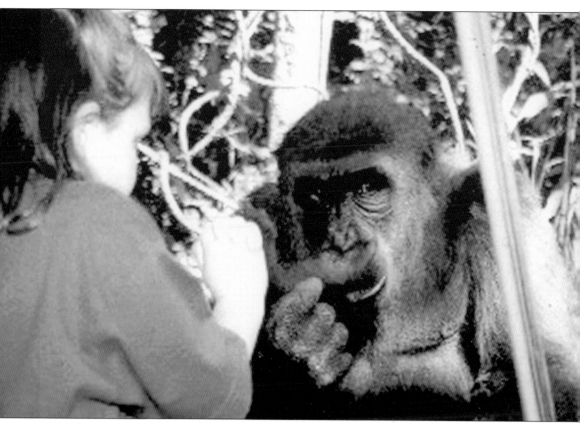

In the Conservation Theater in the Congo exhibit there is an eight minute film on gorillas that was filmed at World Conservation Society sites in Central Africa. At the film's conclusion, the projection screen rises and curtains open revealing views of the gorilla habitat, often with a gorilla looking into the theater and watching the visitors enter the exhibit. Eye to eye contact is made through the clear glass that is installed from top to bottom. The exhibit has heated pads built into the floors near the windows to encourage the gorillas to go near the front on cold days. On warm days, the same ducts are used to supply cool water. (© WCS.)

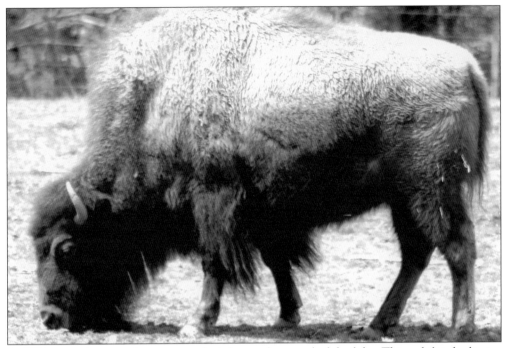

In 1971, a new bison enclosure opened at the southern end of the lake. This exhibit duplicates a Western Plains landscape with a protected grove of trees in the center and a stream running along the edge. The walkway gives the visitors an opportunity to get a closer view of the bison as well as to study the interpretive graphics that give the history of the American Bison Society, founded in 1905, and the role it played in saving the bison from extinction. (Judith Wolfe.)

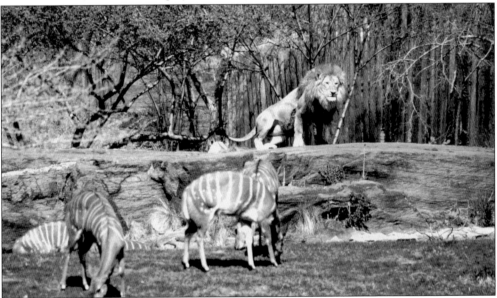

Lion Island opened in May 1941. Wide and deep moats separate the lions from the other animals with no obvious fencing. The aim of renovated exhibits was to show living collections according to their natural habitats. Other animals, including the Nyala deers, are all separated from the lion with no obvious fencing. (Emil Rossdeutscher.)

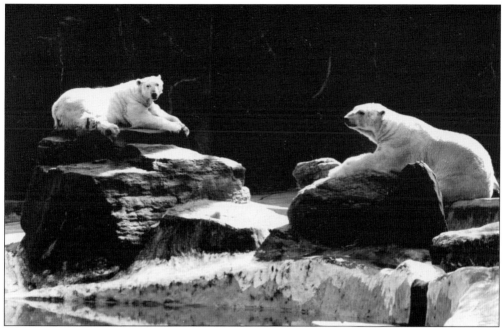

The polar bears have artificial rocks and a large pool. The keepers put out enrichment items that would include frozen fish in pails, large floating drums, and vegetables and fruits hidden in the nooks and crannies of the rocks to encourage hunting and foraging behaviors. (Emil Rossdeutscher.)

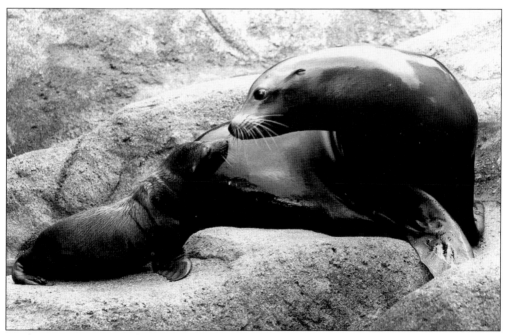

Sea lion pups are always the center of attention at the Bronx Zoo. The mother and pup recognize each other by their smell, bark, and whiskers. The sea lion pool was renovated in 1980 to allow for the addition of rock work that imitates a sea lion rookery on the California coast. Visitors can view the sea lions from all sides. (Judith Wolfe.)

All animals big and small can be found at the Bronx Zoo. The Butterfly Garden is a rite of spring. Here a young man is enjoying the personal elements of this exhibit. There are graphics around the exhibits that explain the life cycle of the butterfly as well as cut outs where the youngsters can become part of the exhibit. (Joanne Steinhardt.)

There are many graphics in the exhibits and along the pathways. This sign catches the eye and brings a smile: "Most Cat Owners Clean up Fur Balls—we weigh ours." It also tells the visitors the mission of the Bronx Zoo is to breed animals successfully and give them a quality of life as well as to give the visitor an enriching experience. (Joan Scheier.)

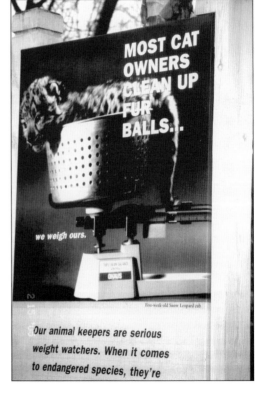

MOST CAT OWNERS CLEAN UP FUR BALLS...

we weigh ours.

Five-week-old Snow Leopard cub

Our animal keepers are serious weight watchers. When it comes to endangered species, they're

A popular exhibit was Senor Lopez a jaguar in the lion house in 1906. He was the first inhabitant of the lion house to take over the first finished cage. Two rooms at the lion house were set aside for the use of artists. Senor Lopez died in 1914 and two figures of his likeness were sculpted by Anne Hyatt Huntington and presented to the Zoological Society in 1937. They stand on the slope between the Fountain Circle and Astor Court. (Joan Scheier.)

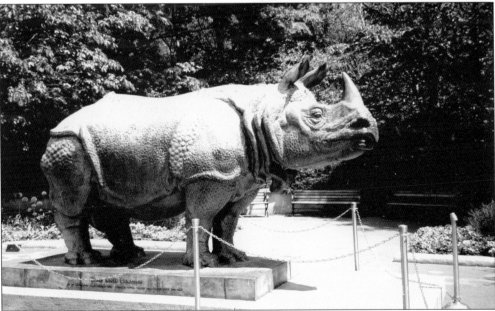

When you pass through the center of the old elephant house, now known as the Keith W. Johnson Zoo Center, you will be greeted by two larger than life casts of two rhinoceroses that were created in 1936 by Katherine Weems, depicting an Indian rhinoceros at the Bronx Zoo. The bronze casts were made in 1989 and during the Christmas holiday may be seen wearing a holiday wreath around their necks. (Joan Scheier.)

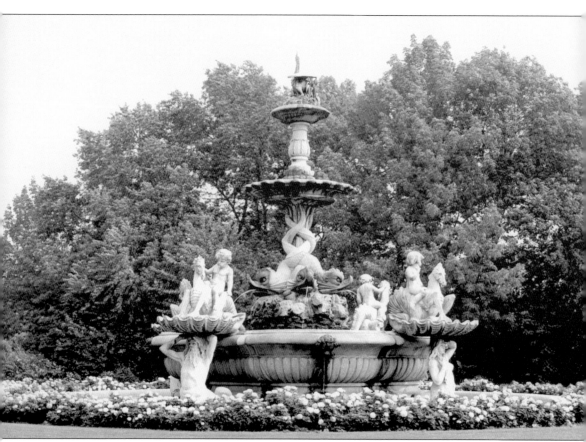

The ornate fountain known as the Rockefeller Fountain stood on the grounds of a wealthy resident of Como, Italy. William Rockefeller, John D. Rockefeller's brother, bought it for about $25,000 and transported it in numbered boxes. It was reassembled on the east side of Baird Court, behind the sea lion pool. It was moved in 1910 to the center of the Concourse Parking Circle. The sculptor was Biagio Catella. The fountain was declared a New York City landmark in 1966. (© WCS.)

Three

THE PROSPECT PARK ZOO

The Prospect Park Zoo began as a small menagerie located within Prospect Park. Elks, bears, and zebras were occupants for this new menagerie in the park. It was officially opened as the Prospect Park Zoo in 1935 having been built by the Works Progress Administration (WPA), under Robert Moses, parks commissioner of New York City. This zoo had the typical architecture of the time, red brick with white trim, friezes, statues, cages with bars, and sea lions reclining on concrete platforms.

The zoo, under the Wildlife Conservation Society, replaced the old zoo in 1989. Naturalistic habitats replaced bars, cages, and pits. Included in the renovation were three major exhibits, "World of Animals," "Animal Lifestyles," and "Animals in Our Lives." Each of the three areas has the specific goal of reaching out to children.

There are almost 400 animals of 82 species located in this 11-acre zoo located just steps off of Flatbush Avenue. There is a creature for visitors of all ages. The sea lion enclosure in its naturalistic rocky setting will impress adults while their barking antics will please the children. Children will enjoy feeding barnyard goats, horned sheep, and alpacas.

Historians will enjoy noting that the best of the old zoo remains in friezes from the *Jungle Book* by Rudyard Kipling that still adorn the buildings. The lioness and her cubs' statue is located at the center of the zoo. The red brick buildings with white trim are the same on the outside, but all have state of the art, up-to-date, naturalistic exhibits.

—Joan Scheier

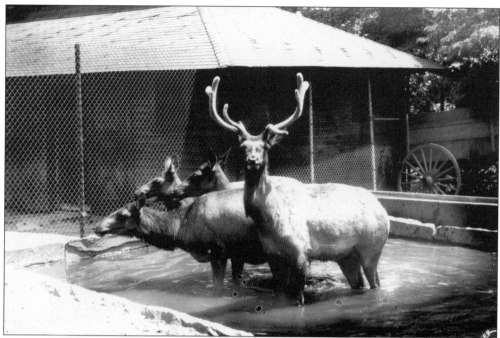

All of the zoos in New York City began in a park: Central Park, Bronx Park, Barett Park, Battery Park, Flushing Meadows Park, and Prospect Park. One of the first residents was elk, also known as Wapiti, which freely roamed the park and then were placed into fenced areas. The Menagerie grew in the late 1800s into a collection of animals shown in enclosures and cages that were built as they arrived. (Prospect Park Archives.)

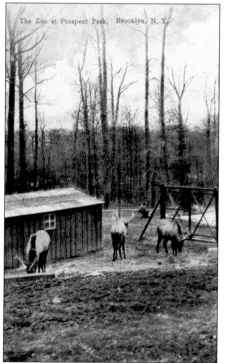

An early souvenir postcard postmarked 1910 contains the caption "The Zoo at Prospect Park." The wooden structures and fences were built along a path that the visitors could stroll through and view the animals in a natural backdrop of the park. It would be 25 years before a formal zoo would open in 1935 with brick buildings and iron fences. (Joan Scheier.)

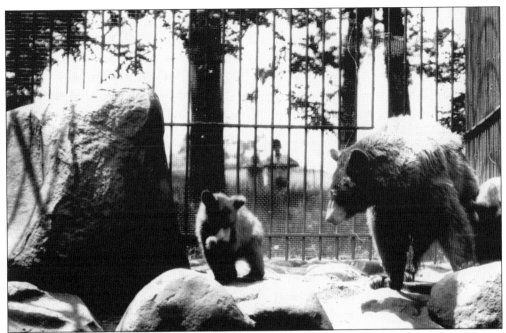

This postcard is an image from the early 1920s that appeared in the *Brooklyn Eagle* titled "New Bear Cage at the Prospect Park Zoo." New cages were installed as the Menagerie grew. When the zoo formally opened in 1935, the bears had more room and a natural looking habitat that included rocks from the park. (Prospect Park Archives.)

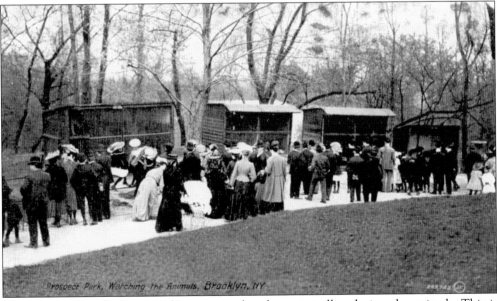

The Menagerie in Prospect Park was a popular place to stroll and view the animals. This is a scene from the early 1900s. The cages were small and not built for maximum viewing. The Menagerie fell into disrepair and Robert Moses selected the site for a formal zoo. It was built by the Works Progress Administration (WPA) and opened in July 1935. The WPA employed workers to construct the zoo in red brick and white trim, and paid artists to add friezes, murals, and statues. (Joan Scheier.)

53

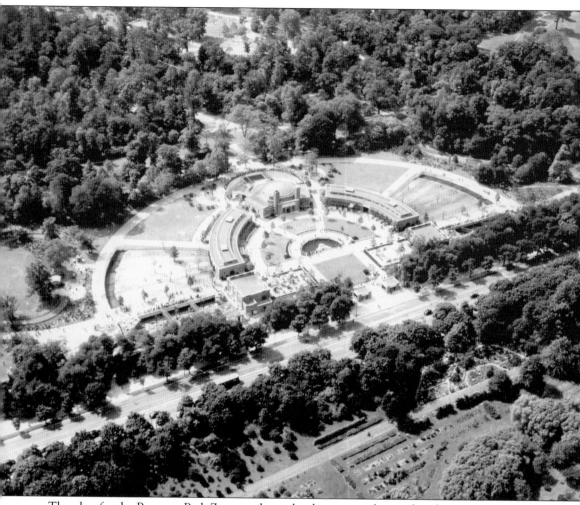

The plan for the Prospect Park Zoo was drawn by the same architect that designed the Central Park Zoo, Aymur Embury II. The fan shape was considered ingenious for permitting observation of both outdoor and indoor cages. The sea lion pool would be in the center following the plan of other zoos designed in New York City at the time. At the front would be a dome that would be the elephant enclosure. The zoo would be steps off of Flatbush Avenue, opposite the Brooklyn Botanical Gardens. (NYC Municipal Archives, WPA records.)

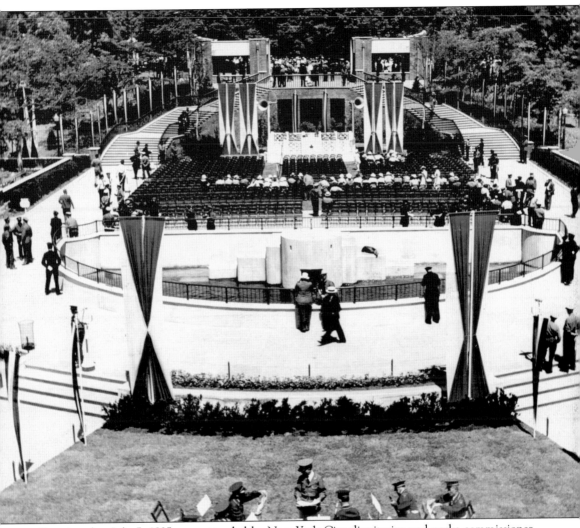

Opening day, July 5, 1935, was attended by New York City dignitaries and parks commissioner Robert Moses. The concrete sea lion platforms were installed in the center. At the top is a podium and seating for invited guests. The band is at the ready for the opening day ceremony. Concerts were given at the zoo during summer evenings. (NYC Municipal Archives, WPA records.)

Friezes adorned many of the buildings, telling the story of Mowgli, from the *Jungle Book* by Rudyard Kipling. They were sculpted by F. G. Roth who sculpted the friezes found at the Central Park Zoo. (NYC Municipal Archives, WPA records.)

Visitors could view the animals in their outdoor cages separated by railing and iron bars. A small sign telling the name of the animals was the only information given. It is important to remember that zoos that were built in the 1930s were in the context of the time and were considered a big improvement over the menageries built with small enclosures as the animals arrived with no thought about species placement. With time and increased knowledge about animal care and habitat management, this type of enclosure became obsolete in all the zoos in New York City starting in the 1980s. (NYC Municipal Archives, WPA records.)

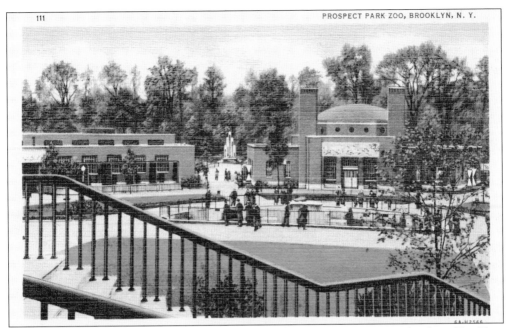

This is a view from the staircase leading to the zoo from Flatbush Avenue. The domed building in the center was the elephant house. The architecture was red brick with white trim. The friezes remain on the renovated buildings of today. The domed building at the center which was the elephant house today contains the Animal Lifestyles exhibits, including the Hamadyras baboon exhibit, which occupies the former elephant enclosure. (Joan Scheier.)

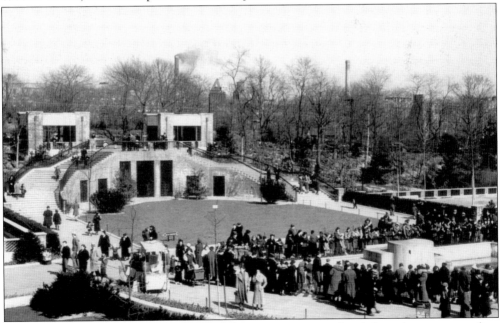

This view shows the main entrance and the twin staircases that led to the center sea lion pool. The zoo of 1935 had large enclosures and special attention was paid to the welfare of the animals. Items were put into the cages for the comfort of the animals such as high shelves for the cats to sleep on and limbs for the primates to climb on. (Prospect Park Archives.)

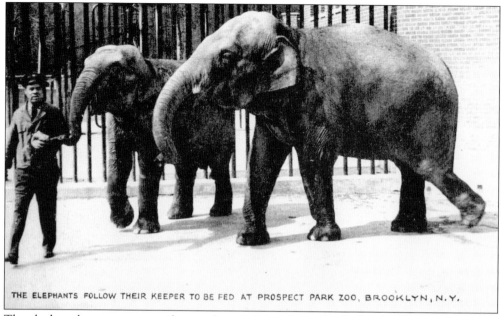

THE ELEPHANTS FOLLOW THEIR KEEPER TO BE FED AT PROSPECT PARK ZOO, BROOKLYN, N.Y.

The elephant keeper wore a uniform and carried an ankus, a hooked rod, as he led his charges inside to be fed. Later, in the 1960s, the zoo used natural materials such as sand and grass for the elephants to stand on in their enclosure. (Joan Scheier.)

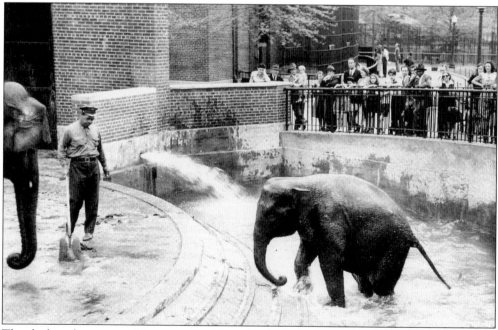

The elephant house was a large round building that had a large outside area. This postcard dated 1938 shows the elephants enjoying a cool shower and pool. The keepers at this time were usually park employees, not specialized personnel. The animals bonded with their keepers and made moving these large mammals possible. (Joan Scheier.)

58

Large ornate bird cages were part of the zoos' exhibits. The cages housed birds in the spring and summer and small farm animals and plants during the fall and winter months. The weathervane atop the cage is another example of decorative arts incorporated into the zoo. Paving stones that were used in 1935 are still in use in the zoo today. (W. Conway, WCS.)

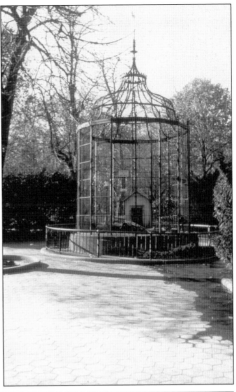

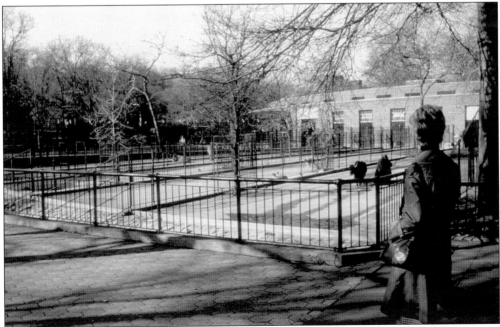

Hoofed animals were in enclosures similar to those at the Central Park Zoo. Elk, buffalo, and llamas all were in the same area but separated by fencing. The animals would have their own areas that would allow them to feed and exercise. The building stands today and the markings of where the cages were mounted can still be seen. (W. Conway, WCS.)

The Prospect Park Zoo of 1935 exhibited both polar bears and Asiatic black bears. The Asiatic black bears have a distinct white patch on the chest which is sometimes in the shape of a V. This postcard is dated 1949. The bear dens had rocks for climbing with a water pool at the bottom of the enclosure. (Joan Scheier.)

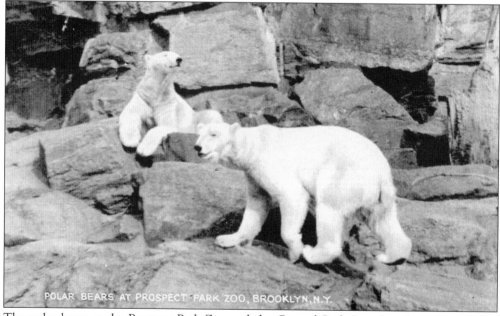

The polar bears at the Prospect Park Zoo and the Central Park Zoo shared similar types of enclosures. Both were built by the Works Progress Administration (WPA) during the Depression, under Robert Moses, parks commissioner. Here are two polar bears on their rocky habitat. There was one viewing area at the front of the cages. (Joan Scheier.)

60

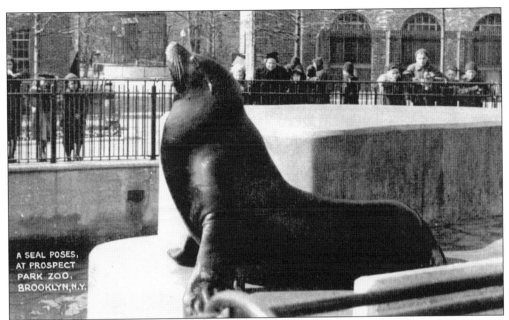

A SEAL POSES, AT PROSPECT PARK ZOO, BROOKLYN, N.Y.

This sea lion enclosure is at the center of the Prospect Park Zoo. The sea lions had concrete platforms that were replaced with naturalistic rock formations in 1993. The arches of the building that housed the big cats can be seen on the right. (Joan Scheier.)

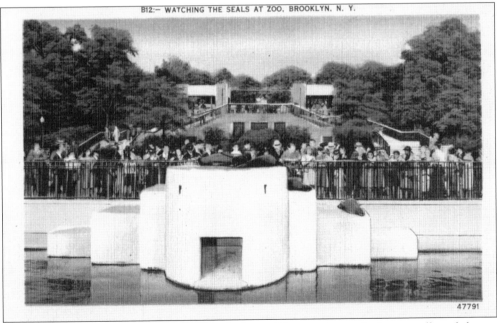

B12:— WATCHING THE SEALS AT ZOO, BROOKLYN, N. Y.

47791

Sea lions can be seen lounging atop their platforms. The opening at the bottom allowed the sea lions to get away from bad weather. The viewing area was a large semi-circle. All the buildings of the zoo could be seen from the center at the sea lion pool. (Joan Scheier.)

This photograph shows an indoor enclosure that was typical of the New York City zoos of the time. Cats would have an outdoor area as well as an indoor enclosure. The window ledge is a natural climbing tree for the big cats and allowed them a view of the outside. The enclosures were barren of any trees or items that would encourage natural behaviors, which would be found in all the New York City zoos today. (W. Conway, WCS.)

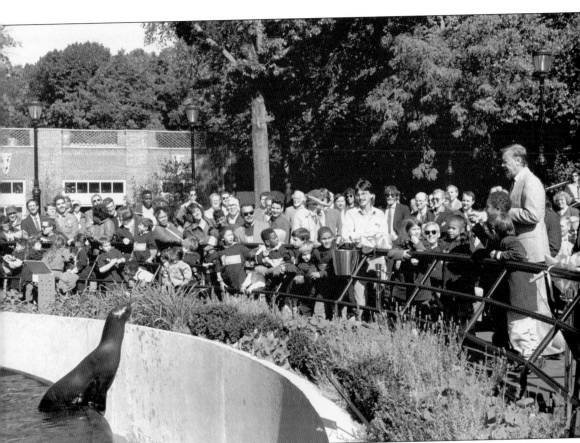

As with the other zoos of the 1930s, the Prospect Park Zoo needed a major renovation. The buildings were not demolished, but the insides were gutted to make room for updated and larger exhibits. Larger animals such as bears and elephants were moved to other zoos. When the zoo reopened on October 5, 1993, it became the fifth facility of the Wildlife Conservation Society network of wildlife parks in New York City. The sea lion exhibit doubled in size and concrete platforms were replaced by naturalistic rocks that replicated the natural shorelines. The zoo is only one part of Prospect Park, which includes a carousel just steps away and many historic houses opened to the public. There is also a boathouse, a band shell, and a world class Botanical Garden. (© WCS.)

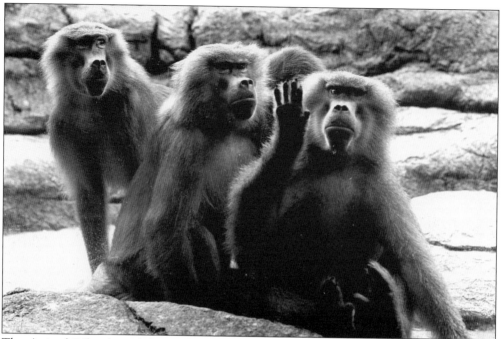

The Animal Lifestyles exhibit is the habitat of Hamadryas baboons. Here the visitors can interact with these curious mammals through floor to ceiling clear glass. This interaction provides enrichment for the monkeys and enhances the visits of both adults and children. They have long coarse fur and will grow to a height of two feet. This exhibit, as with all the new exhibits in the New York City zoos, was built with the needs of the baboons in mind. Graphics that tell about these primates are placed all around the exhibit. (© WCS.)

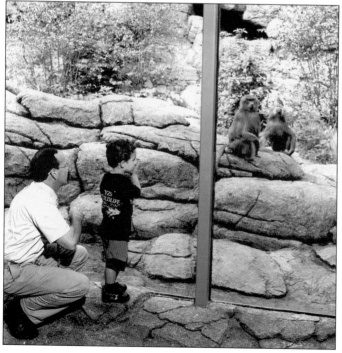

A wider view of the Hamadryas baboon enclosure shows the use of natural elements such as rocks, trees, hiding places, and sleeping ledges. The Prospect Park Zoo has many educational programs including special keeper chats, wildlife encounters, docent talks, and zoo camp. All the programs help to educate the public about the animals in the zoo and the issues of conservation. (© WCS.)

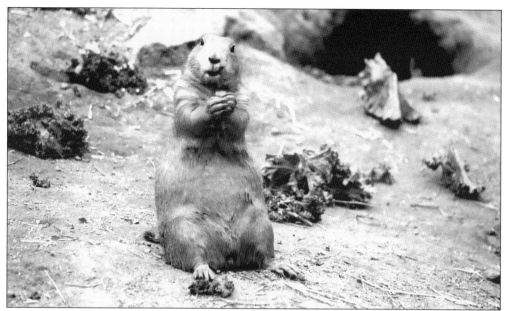

Prairie dogs are not dogs but a type of ground squirrel. They are social animals that live in groups, with a complex of burrows called towns. In the World of Animals exhibit youngsters can enter a plastic dome and come face to face with the prairie dogs as they enter and leave their burrows. (Emil Rossdeutscher.)

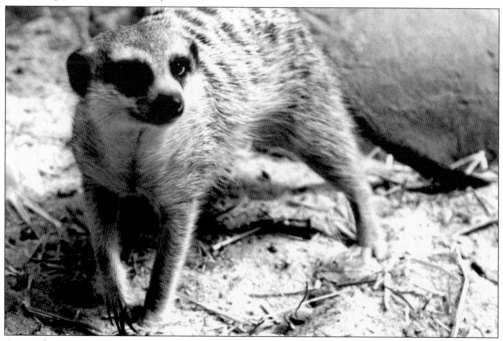

A meerkat is not a cat but a mammal related to the mongoose family. Their habitat at the Zoo closely resembles the dry open country they would feel at home in. They are sleek and furry and about the size of a squirrel. When they are stiffly standing at attention they are scanning for danger. Keepers provide enrichment by placing insects, crickets, fruits, and other food items inside long hollow cardboard tubes so that they can use their natural digging skills. (Judith Wolfe.)

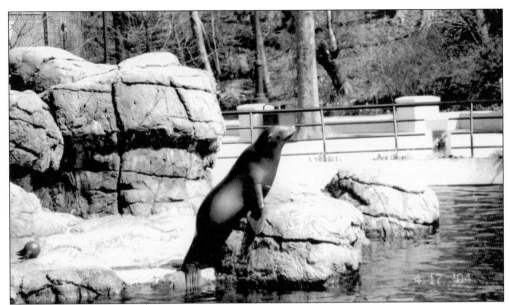

The sea lion pool is twice the size of the space of the 1930s. Keepers hand feed the sea lions three times a day while telling the visitors about the animals. As you enter the zoo from Flatbush Avenue you can hear the sea lions barking. The Prospect Park Zoo includes a Discovery Domestic Area that includes owls, rabbits, turkeys, cranes, and kangaroos. The zoo is constantly adding new elements to their exhibits to help educate the public and provide additional enjoyment. (Joan Scheier.)

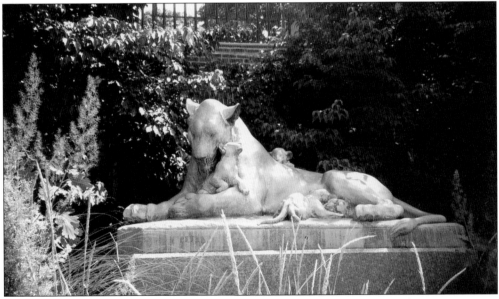

The *Lioness and Cubs* sculpted by Victor Peters in 1899 is located at the base of the twin staircases as you enter the zoo. The statue was located inside Prospect Park before 1934 when Robert Moses, parks commissioner, moved it into the zoo to protect it from children using the lioness as a slide. He also wanted to add to the animals in art form that were an integral part of the New York City zoos. In the 1990s the sculpture was moved from a pedestal in the zoo drive to its present location behind a holly hedge, protected by tiny bushes. (Joan Scheier.)

Four

THE STATEN ISLAND ZOO

The Staten Island Zoo is the only New York City zoo that is not part of the Wildlife Conservation Society. However "New York's Biggest Little Zoo" has much in common with the Central Park and the Prospect Park Zoos. The WPA used solid brick architecture, winding paths, and a park-like setting. The aim of the Staten Island Zoo was to blend in with the surrounding community. Flower beds, tall trees, shrubs, and quiet walkways lend itself to the surrounding neighborhood. In fact, the zoo's entire eight and a half acres is surrounded by a serene tranquil neighborhood of older homes, established prior to or around the same time that the original zoo was built. Because of its size, it is also a zoo that can be seen in one day, leaving enough time to revisit favorite exhibits.

The Staten Island Zoo has always been known for its reptile collection (especially for its collection of venomous snakes) and its emphasis on education. In fact, the zoo is host to over 20,000 children a year through their extensive agenda of educational programs. Karl Kaufield, a founding father of the zoo and a world-class herpetologist, is still quoted today in many zoological circles. His entire mission was to educate the public on the many wonders of reptiles.

The Staten Island Zoo, like all zoos, has changed since the 1930s. The animals were in cages and the exhibits were sterile with little to engage the resident. Now they can be seen in a natural setting with the keepers providing enrichment specific to each animal. Although there is much to see outdoors, including special attractions such as the red pandas and emus, the indoor exhibits have been dedicated to collections from the African Savanna and the tropical forest. There is also a newly renovated reptile wing, featuring "The Fear Zone," which is scheduled for completion by the fall of 2006. The zoo even boasts their own little aquarium with everything from seahorses and sharks to clown fish, not to mention a moray eel. All this considered the most popular attraction is still the Children's Center and Contact Area. Here, a child can actually experience what a day on a farm would be like: Sarah the cow welcomes visitors as they cross the quaint covered bridge (where children's songs play continually) into a little farm. Chickens, rabbits, ducks in their own pond, Sicilian (miniature) donkeys and miniature horses, goats, llamas, and deer all inhabit the Children's Center to the delight of many visiting children and parents alike.

Clearly the Staten Island Zoo is an oasis in a city craving for an experience that is fun, educational, and affordable. If ever on Staten Island, driving to or from Brooklyn or New Jersey, be sure to stop by and see us. It is guaranteed to be an enjoyable stay!

—John Caltiabano, director, Staten Island Zoo

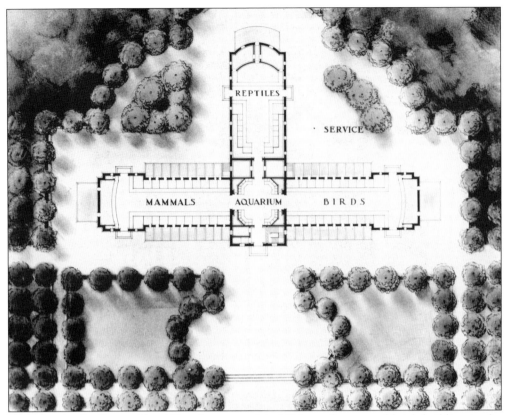

REPTILES

SERVICE

MAMMALS AQUARIUM BIRDS

The plan for the Staten Island Zoo that opened in 1936 was for one red brick building in the shape of a T. The center of the T would be a rotunda that would house the aquarium. Mammals and birds would be on either side. The straight leg of the T would house the reptile collections. The plans included an auditorium for speakers and classrooms for school and adult groups. The second floor housed the library, animal hospital, and laboratory. (NYC Municipal Archives, WPA records.)

Barrett Park was the location of the zoo and also the name of the zoo. As time went on it became known as the Staten Island Zoo. As with other zoos in New York City, a collection of animals in small cages within Barrett Park where Broadway and Clove Road act as boundaries containing the eight and a half acres of the zoo. The Staten Island Zoological Society secured the land for the zoo where it would be located. Construction began with the Civil Works Administration (CWA) and was completed by Works Progress Administration (WPA). All the New York City zoos of that era used red brick with white trim and included ornate chimneys atop the buildings. (NYC Municipal Archives, WPA records.)

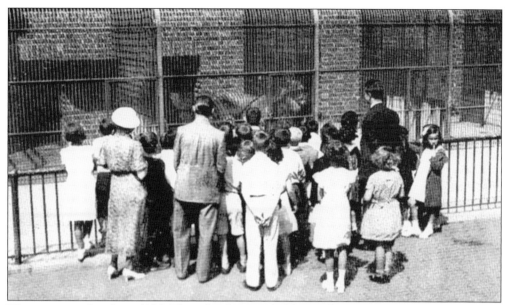

The zoo opened in June 1936. The school groups led by teachers were always charmed by the lions. Educational programs included demonstrations for biology students, meetings of natural history groups, lectures and demonstrations for the public. The zoo was open until 10:00 p.m. twice a month allowing for less crowded conditions and a chance to ask questions of the curatorial staff. (Staten Island Zoo.)

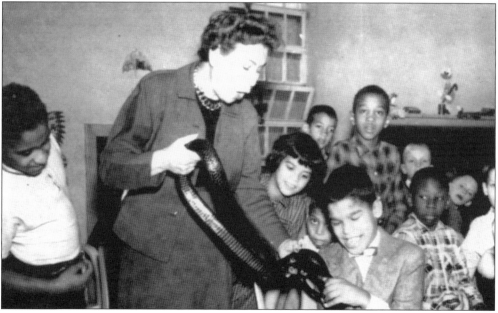

Dr. Patricia O'Connor, staff veterinarian 1945–1970, considered educating the public and especially children an integral part of her job description. Her visits included trips to hospitalized children to give them an opportunity to touch and learn about an Indigo snake. Handicapped children were invited to the zoos for lectures by Dr. O'Connor. Included in her educational programs were courses for high school teachers, nature clubs, hobby groups and monthly slide lectures. Her career combined caring for the animals and educating the public. (Staten Island Zoo.)

From the beginning, the Staten Island Zoo was noted for its reptile collection. In the reptile wing, glass would be placed between the exhibits and natural lighting would come from skylights and glass shingles, allowing visitors the best opportunity to see the exhibits. Murals painted by WPA artists depicted the natural habitats of the reptiles that could be viewed in different cages. (Staten Island Zoo.)

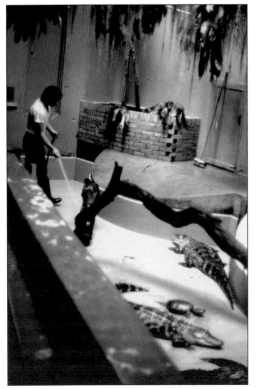

At the far end of the reptile wing was a large pool for alligators and turtles. Olive Earle, a WPA artist painted the mural depicting natural habitats. Other exhibits had murals painted by WPA artists. The exhibit also included items such as sand and watering pools, which added to the natural feeling of the exhibit for both the visitors and the reptiles. This photograph shows a keeper cleaning the tank. Alligators are large meat-eating reptiles that spend a lot of time in water and enjoy natural sunlight when stretching on the rocks. (Staten Island Zoo.)

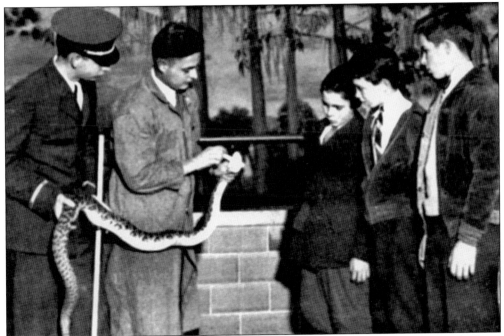

Carl Kauffeld, curator of reptiles of the Staten Island Zoological Society, is displaying the fangs of a diamond back rattlesnake to three young visitors. This photograph taken in 1937 shows how the collection and education go hand in hand. There were many myths surrounding snakes. Lectures and hands on experience with keepers helped the visitors get a better understanding of the reptiles. (Staten Island Zoo.)

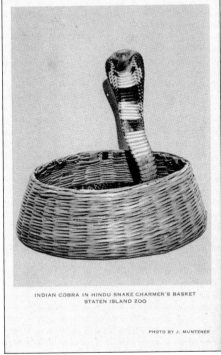

INDIAN COBRA IN HINDU SNAKE CHARMER'S BASKET
STATEN ISLAND ZOO

PHOTO BY J. MUNTZNER

The Indian cobra is an example of a snake that was the cornerstone of the reptile collection. This is a highly venomous snake that feeds on rodents. When threatened, it will raise the front one third of its body and elongate its long flexible neck, ribs, and loose skin to form a disk like hood, on the back of which are markings resembling eyes. (Joan Scheier.)

When the zoo opened in 1936 it claimed to be the first education zoo in America. From the opening day through today, the reptile exhibits have aimed for a naturalistic habitat. This anaconda, displayed on an early souvenir postcard shows the rocky bottom that would have been natural to this species. Today this eight-and-a-half-acre facility is internationally recognized for its superb reptile displays. Today the tropical rainforest exhibits anaconda snakes, fruit and vampire bats, clouded leopards, black handed spider monkeys, and cotton top tamarins. (Jack Torresi.)

This is an example of the outdoor cages from the 1940s that housed the mammals. On each cage was a sign telling the name of the species and where it could be found. Renovations that were done in the 1980s included a tropical rain forest and an African savannah, where smaller wild cats would be in natural settings. The inside of the buildings were changed but the ornate chimney from the original buildings can still be seen today. The move to larger natural exhibits made it necessary to replace larger animals with smaller animals such as red pandas, lemurs, and howler monkeys. (Joan Scheier.)

Sultana, one of the African lionesses, was shown in a typical enclosure of the time. All big cats had access to both indoor and outdoor cages. The keepers would move the cats in order to clean the cages and feed the animals. The breeding of big cats was successful and cubs were sent to other zoos. In 1967, renovations to the zoo made it necessary to remove the larger animals to other zoos. Many were sent to Guadalajara, Mexico, where a new zoo was being built. (Joan Scheier.)

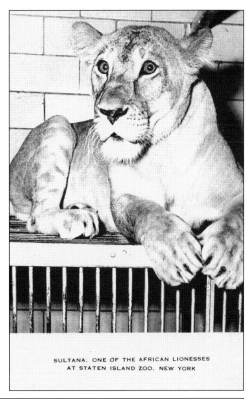

SULTANA, ONE OF THE AFRICAN LIONESSES
AT STATEN ISLAND ZOO, NEW YORK

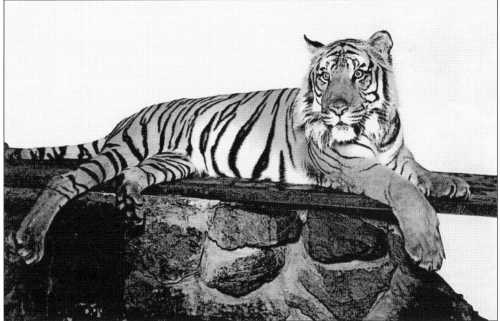

The entire animal and reptile collection housed over 400 species in one building with a wing devoted to mammals. The Siberian tiger was one of the rare species that occupied an enclosure in the mammal wing. The indoor area used natural lighting and included perches for the big cats to repose on. The large cats could also be seen in outside cages. (Jack Torresi.)

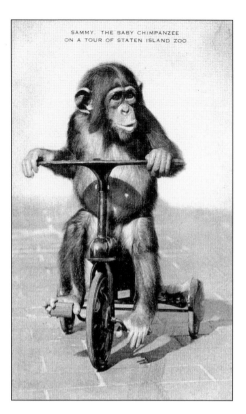

SAMMY, THE BABY CHIMPANZEE
ON A TOUR OF STATEN ISLAND ZOO

Chimpanzees arrived at the Staten Island Zoo shortly after it opened. This postcard from the 1940s states "Sammy, the male chimpanzee on a tour of the Staten Island Zoo." Chimpanzees are quick learners and love to perform and greet the public. (Joan Scheier.)

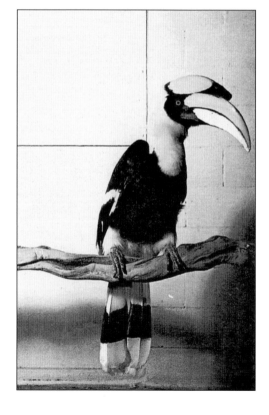

The Great Hornbills occupied a large ornate cage in the bird house. This was a common bird exhibit at the time the zoo opened. The cage included branches to perch on. Keepers would hand feed the birds while the public watched. (Jack Torresi.)

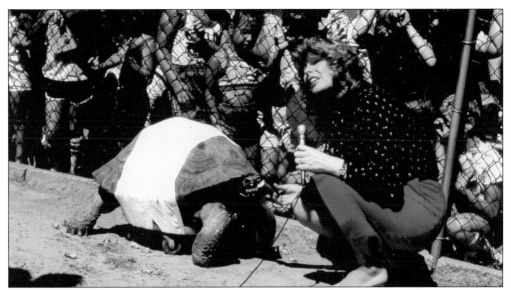

Jalopy, a giant tortoise, was donated to the zoo in 1937. He weighed 85 pounds upon arrival and grew to almost 150 pounds. Jalopy enjoyed being let out into the sunshine and greeting visitors. A growth was discovered on his left shoulder that made it difficult for him to move after surgery. A skateboard was placed underneath him and attached with gauze to hold it in place. He became known as the tortoise on wheels and became a media darling at the zoo. After his death in 1983, topiary in his likeness was made in his honor. July 25, 1984, was declared "Jalopy Day." (Staten Island Zoo.)

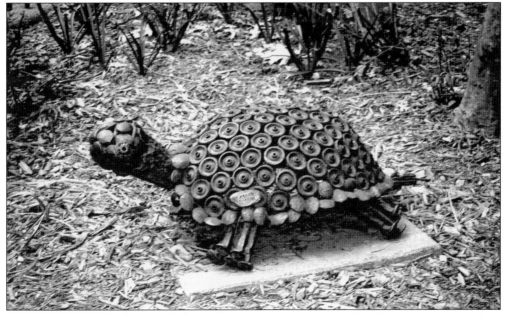

The cast iron turtle right outside the children's farm is a tribute to the Galapagos tortoise Jalopy who resided at the zoo for over 45 years. Jalopy's famous shell was placed behind a glass enclosure along with replicas of other tortoises and turtles. The tortoise on wheels was known the world over. After his death, it was confirmed that he was a she. This is a small monument to a very large tortoise. (Joan Scheier.)

This is an outdoor enclosure showing a lion lounging on a raised shelf. All the zoos in New York City have one thing in common when it comes to saving the best of the architecture. Whether the buildings were demolished or renovated, paving stones, chimneys, weathervanes, brick trim, friezes, and statues were kept in their original locations. This gave the new zoos a feeling of the old zoo, while the inside contained new naturalistic habitats and exhibits. The ornate chimney was common in all the zoos built by the WPA in the 1930s. This building was converted into a state-of-the-art animal hospital in 1986. (Staten Island Zoo.)

The opening of the animal hospital also marked the 50th anniversary of the zoo in 1986. The hospital is equipped with a quarantine area, nursery, incubator, X-ray unit, and examination and treatment rooms. The hospital was an important element that allowed the zoo to receive accreditation by the American Zoo and Aquarium Association (AZA). All New York City Zoos are accredited by the AZA. There are animal designs around the windows as well as live birds enjoying the ledges of the building. (Staten Island Zoo.)

All New York City zoos include an education department and use volunteers to help the visitors learn about the collection. This docent is holding a live snake so that children can get a close look and ask questions that the docent will answer. This approach helps the visitor to understand why snakes are important to the environment. (Joan Scheier.)

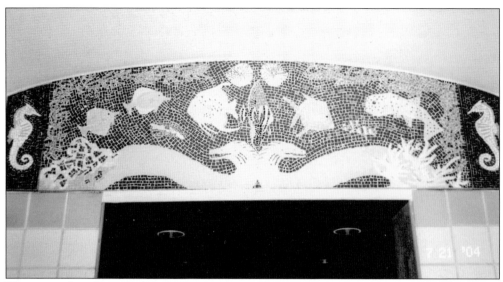

This mosaic found over the door leads to the aquarium. It is one way for visitors to get an idea of what is inside. Most zoos use decorative arts not only to please the eye. Artistic works are incorporated into the zoo exhibit. Inside the aquarium and savannah there are graphics and television screens with videos that tell about the exhibit. In addition to tropical and exotic fish, there are exhibits that include fish that can be found in the waters around New York City. (Joan Scheier.)

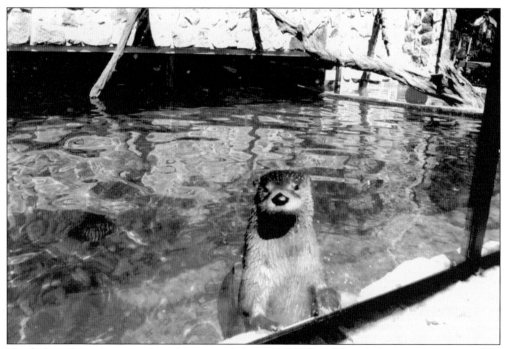

North American river otters have been on exhibit since 1982, and their habitat was constructed by the staff at a cost of $20,000. In 2005, a new enclosure replaced the one that was built 24 years ago at a cost of $750,000. Visitors can watch the otters both above and below the water. The newspaper stated that the "Zoo's new water-loving pals are otter-ly adorable." (Staten Island Zoo.)

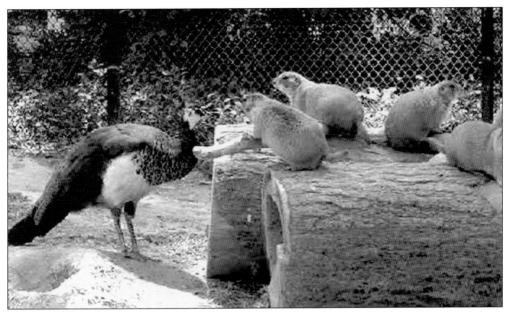

In keeping with exhibits with no bars, it was decided to have more outdoor exhibits that did not need to be roofed in. This fenced in exhibit includes flightless birds such as peacocks and an exhibit of prairie dogs with burrows for digging. This photograph shows how well they get along when the peacock visits the prairie dog exhibit. (Joan Scheier.)

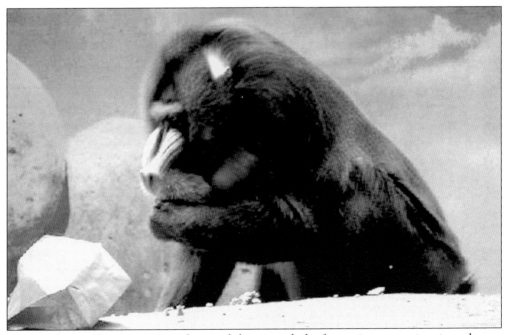

In 1991, the South American rainforest exhibit opened, the first major renovation since the zoo opened in 1936, followed in 1997 by the opening of the African savannah exhibit, which held mandrills, meerkats, servals, lemurs, and Amur leopards. The mandrills are the most colorful mammal with their bright blue muzzle and bright red nose. (Victoria Padavano, SIZ.)

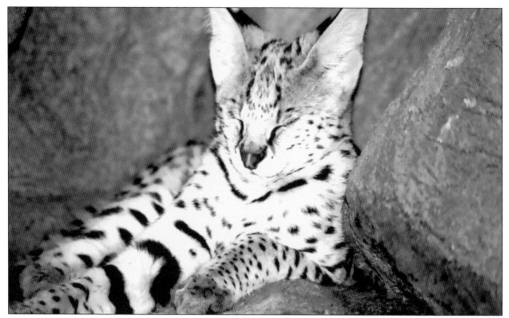

Smaller animals replaced the large lions and tigers. In the 1940s, the zoo had nine different species of cats. An example of a smaller cat is the serval, shown above, which was added to the collection in 2005. The old bird wing would now include not only birds but mammals, invertebrates, and plantings of the African plains. A serval is a wild cat that is a threatened species due to loss of habitat and over hunting. (Eliza Steinhaus.)

Children, animals, education, and art all go together at the zoo. Art work appeared in many diverse forms from WPA artists in the 1930s, and more art has been added in the past 70 years. Today drawings done by local school children can be seen throughout the zoo. The drawings depict many animals that reside at the zoo, as well as some that live in the imagination of the young artists. These colorful panels can be seen in front of the new reptile wing as it is undergoing construction. (Victoria Padavano, SIZ.)

Five

THE QUEENS ZOO

Queens is the last of the five boroughs to have a zoo. Robert Moses, parks commissioner, wanted a zoo without any cages, where animals would be separated from onlookers only by moats and lakes. The Queens Zoo first opened in 1968 at the location of the World's Fair at Flushing Meadows Park, Queens, New York City.

The zoo would include a unique group of tenants—exclusively North American animals including bears, wolves, raccoons, sea lions, deer, and bison. The geodesic dome from the 1964 World's Fair designed by Buckminister Fuller would now be used as an aviary and would house birds found in North America. No lions, tigers, or elephants. The 11-acre site would have 10 animal and bird areas.

In 1980, the Queens Zoo was taken over by the New York Zoological Society, joining the Central Park Zoo, Bronx Zoo, Prospect Park Zoo, and the New York Aquarium. The Queens Zoo would close in 1988 after 20 years to take advantage of advances in zoo technology and animal management and to update exhibits. The zoo reopened on June 25, 1992.

The Queens zoo now includes animals of the Americas, both north and south. Included are American bison, mountain lions, California sea lions, and American bald eagles. South America is represented by the spectacled bears, the only animal of this kind in the zoos of New York City.

Conservation, breeding, and education are all part of their mission. In 1999, a coyote was rescued in Manhattan's Central Park and brought to the Queens zoo to join a coyote group already part of their exhibits.

The Queens Zoo is now run by the Wildlife Conservation Society, headquartered at the Bronx Zoo in partnership with the New York City Parks Department.

—Joan Scheier

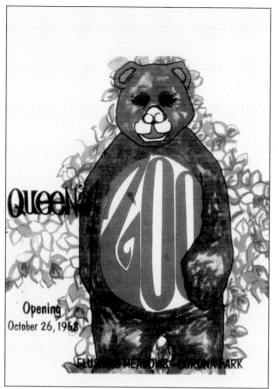

Queens was the last of the five boroughs to have a zoo. Plans called for a cage-less zoo where animals would be separated from onlookers by moats and lakes. This is the cover of the booklet that was given out on opening day at the Queens Zoo, October 26, 1968. The booklet tells about the animals that would be found in the zoo: "Five black bears have settled down in their new home with its miniature mountain and stone covered dens." (Queens Zoo.)

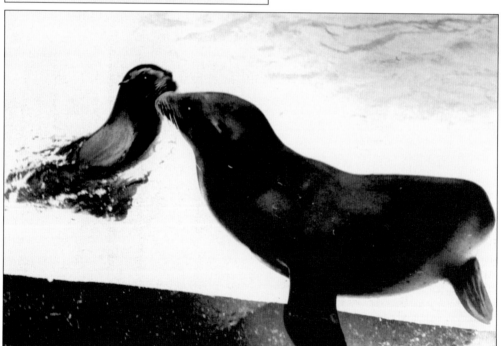

The sea lion pool was kidney shaped with rocks and a beach for sunning and resting. This is a female sea lion with her young. This photograph was the model used in the opening day booklet. (Queens Library, LID, illus, Queens Zoo.)

82

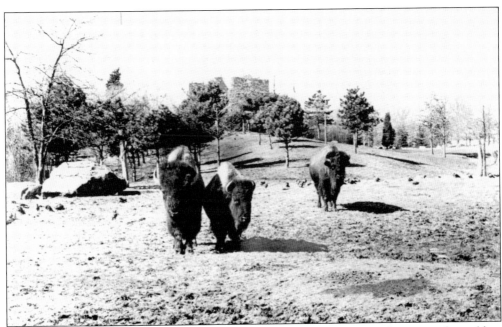

The Queens Zoo has the feeling of a small National Park. The American bison was the emblem of the theme of the Americas. It had two acres to roam. What is unique is that the Queens Zoo is in the center of the borough and the apartment houses in Corona could be seen in the background, while watching the bison graze. (Queens Library, LID, illus, Queens Zoo.)

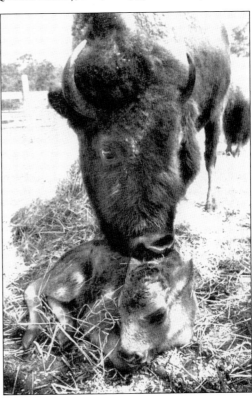

The bison once facing extinction are now part of an active breeding program in the Bronx and Queens Zoos. The bison is the signature species of North America. The American Bison Society, founded in 1905, chose a species that epitomized conservation in the Americas. Success was measured by re-introduction and re-population of the Western Plains. Here is a mother bison (cow) tending to her calf in 1974. The breeding of endangered species is an integral part of the zoos in New York City. (Queens Library, LID, illus, Queens Zoo.)

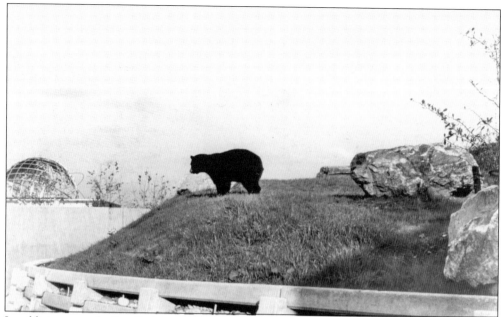

In addition to rocks for climbing and napping, the black bears were able to roam within their open enclosure. The use of dry moats protected visitors from the bears and allowed the bears to engage in natural behaviors. In the background is the "unisphere" from the World's Fair of 1964. As the years passed, the trees filled in and the background buildings disappeared. (Queens Library, LID, illus, Queens Zoo.)

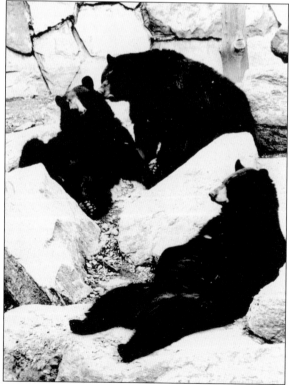

The black bears were comfortable in their naturalistic rocky enclosure right from the beginning. In addition to rocks to climb, they had caves to hide and sleep in and trees to climb. Platforms were built in the trees so that the bears could overlook the zoo and the park. (Queens Library, LID, illus, Queens Zoo.)

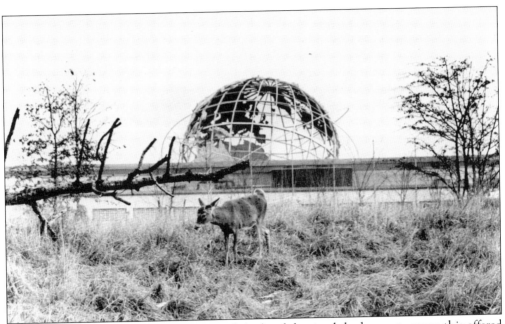

There were no cages to block the views, and the hoofed animals had room to roam; this offered visitors an idea of the animals in their natural settings. The visitors are separated from the foraging deer by a dry moat and unobtrusive fencing. Seen in the background is the unisphere by Gilmore D. Clarke, a symbol of the 1964–1965 Worlds Fair that was held in Flushing Meadows Park. (Queens Library, LID, illus, Queens Zoo.)

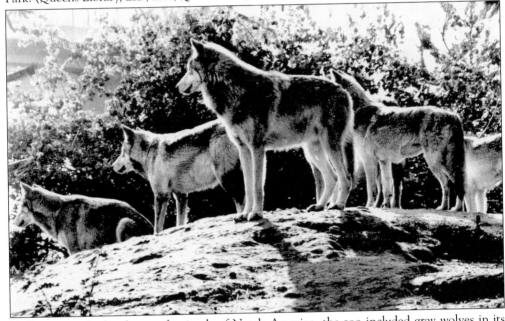

In keeping with the theme of animals of North America, the zoo included gray wolves in its open air exhibit. They could be viewed from a platform with clear glass. At one point the wolf was in danger of becoming extinct, but the threat lessened because of breeding programs at zoos. These programs have enabled the wolves to be reintroduced into the wild. (Queens Library, LID, illus, Queens Zoo.)

The theme of the Queens Zoo was animals of the Americas. The "Gates of Life" was the motif for the grillwork on the gate of the Queens Zoo. It was created in 1968 by architects Clarke and Rapuano and sculpted by Albino Monca, a well-known Italian sculptor. Aquatic plants can be seen on the lowest level. Marine life is on the second level and the top and largest level is for plants, animals, and birds. The gate is 11 feet across and at the highest is 10 feet on both sides. It is an appropriate introduction to the species to be found in the zoo. (© WCS.)

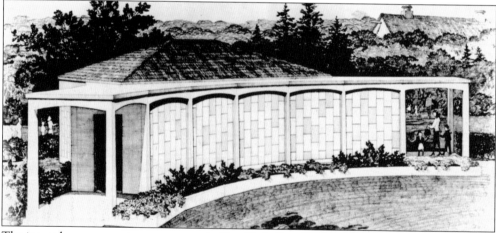

The insect house was unique to any zoo in New York City. The displays would change from time to time and specialists would take visitors behind the scenes where insects could be viewed in a natural environment. The brochure stated, "Visitors will get to know the insects better, though not necessarily like them better." The aim of this exhibit was to show the importance of the insect world to animal, vegetable, and mineral kingdoms of the world. The insect house was open for a short period of time. Today it is used as a maintenance shed and can be seen next to the carousel that was relocated to the park from Coney Island. (Queens Library, LID. Illus, Queens Zoo.)

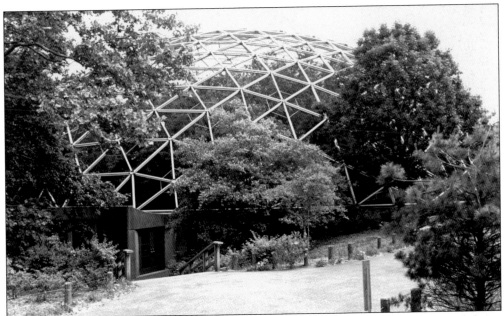

The aviary is a geodesic dome, designed by Buckminster Fuller, and was a scientific exhibit at the World's Fair of 1964, to show how the shape would solve housing problems by allowing more living space. It is a structure shaped like a piece of a sphere or a ball and is formed by a complex network of triangles. The geodesic dome became the center of the Queens Zoo and became the aviary, home to over 40 species of birds. (© WCS.)

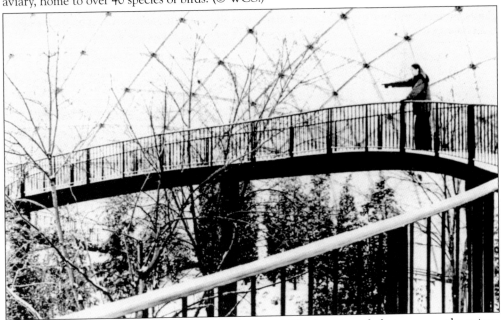

The outside of the geodesic dome could not be altered. The interior, of what was now the aviary, was renovated with a large walkway taking visitors up one path and down through the other side. Along the way there were graphics telling the visitors about the birds in residence. The aviary is open to light through the dome. The birds move freely through the aviary allowing visitors to see them flying and nesting. (Queens Library, LID, illus, Queens Zoo.)

Advances in zoo exhibits and animal management made it necessary to upgrade the exhibits even though the zoo had been open for less than 25 years. The sea lion pool was enlarged and a new beach was added. New exhibits were created for pumas, bobcats, prairie dogs. The children's petting zoo would be redesigned. The areas for wolves and bears would be redesigned. The zoo reopened in 1992 with new larger exhibits for the existing animals and habitats that welcomed new animals as well. (© WCS.)

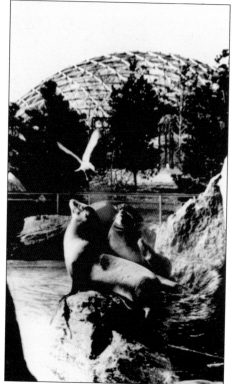

The sea lions bask in the sun with the aviary, a geodesic dome, in the background. The rocks and the sea gulls give this exhibit a natural feeling. The sea lions at the Queens Zoo are all males, and weigh over 800 pounds. (Queens Library, LID, illus, Queens Zoo.)

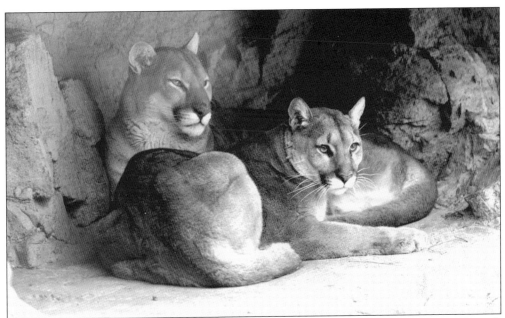

The mountain lion, also known as a cougar, puma, or panther, fit in with the theme of North American animals. Here they can be seen inside a rocky cave. There are two viewing windows to watch cats that are active during day and at times their behavior resembles a house cat. They can be found all through out the United States including all four deserts. Keepers put food in the enclosure to encourage hunting behaviors that would be found in the wild. (© WCS.)

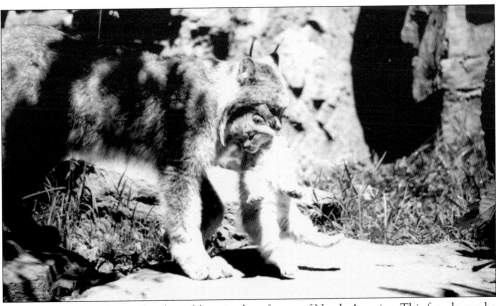

The lynx is part of the cat family and lives in deep forests of North America. This female can be seen carrying her kitten from one part of the enclosure to another. Here the visitors can view these cats through a series of vertical wires, rather than thick bars. The enclosure is open to the air so that they can sniff the air and try to leap at a bird that is flying over the netting. There are many tree limbs, made for resting, that are located both in the shade and sun. (Emil Rossdeutscher.)

On January 8, 1997, twin spectacled bears arrived from the Calvary Zoo in Canada. (They were three years old at the time of this photograph.) To celebrate their first birthday, the zoo declared "twins day." In the photograph, the bears are atop the twin towers. Sharing the twin day are twin volunteers and keepers. Arrivals are always a happy event at the zoo and it is an important contribution to the continuation of a species. (Queens Zoo.)

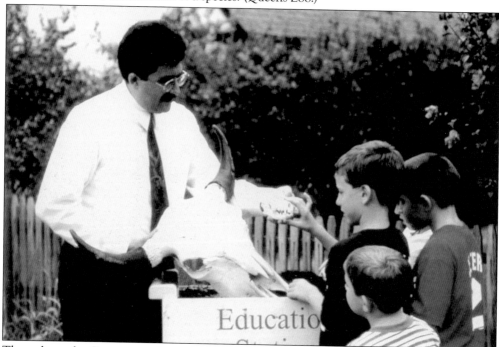

Throughout the Queens zoo there are Education Stations, which are manned by education or docent staff. Here a group of children are comparing the differences between the sizes of a cow skull with those of other animals. There are many on-going educational programs that include sheep shearing, bison bonanza, and migration sensation all with the emphasis of learning and having fun. (Queens Zoo.)

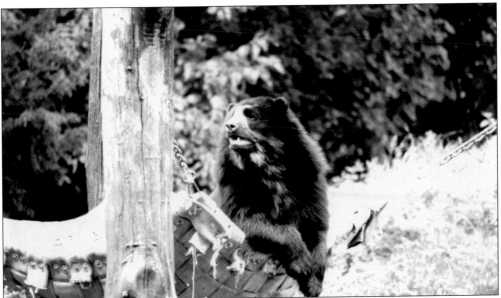

The theme of the Queens Zoo became animals of all the Americas. That included North and South America. The spectacled bear, from South America, gets its names from the markings around their eyes. These markings are unique to each bear and can be used for identification. There are trees to climb and a pool to cool off in. The bears are separated from the public by a large dry moat. The bear above is enjoying the view from a hammock the keepers have made for the viewing pleasure of both visitors and bears. (Emil Rossdeutscher.)

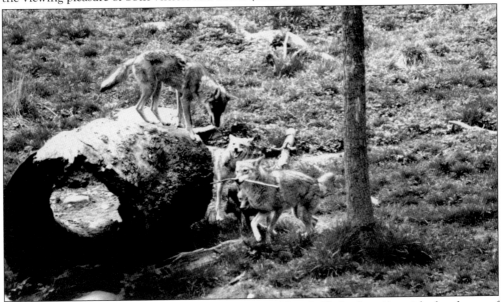

When the zoo opened in 1968 it was home to a wolf pack. Today keeping with the theme of animals from the Americas, it reopened with a coyote troupe. Otis, a coyote who was found in Central Park, was rescued and sent to join the troupe at the Queens Zoo. This was the only facility in the New York City Zoos that had a coyote pack. He joined the group and soon became their leader. They can be seen from an elevated platform on a covered bridge with nothing to block the view. (Emil Rossdeutscher.)

The bison is an appropriate emblem for the Queens Zoo. This zoo has a continuing role in the breeding and conservation of this breed that is an American icon. The New York City zoos, starting in the 1880s, have brought the American bison back in increasing numbers, even though they were once thought to be on the verge of extinction. (Joan Scheier.)

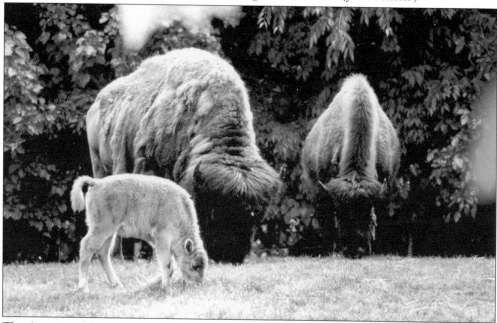

The American bison, once nearly extinct, has been successfully bred at the Central Park Zoo, the Bronx Zoo, and the Queens Zoo. Here is a new calf that was born in 2002. The breeding programs are overseen by the Survival Species Plan (SSP), which selects the breeding animals at the zoo. In some cases animals are sent to other zoos for breeding to create a diverse animal herd. When the calf is born it looks much like a cow. The natural habitat contains many shade trees and a mound of mud and dry sand for them to dust themselves off. (Emil Rossdeutscher.)

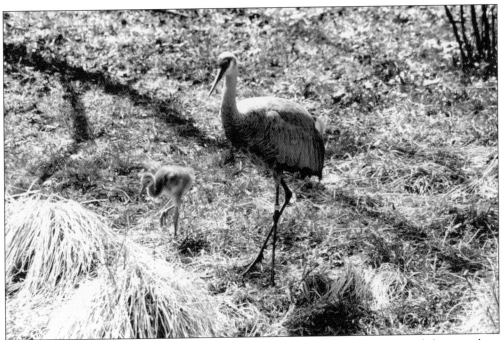

A waterfowl marsh has always been a part of the Queens Zoo. The aim of the exhibit is to show the need to retain the millions of acres of wetlands that still exist in our country. The sand hill cranes occupy space in the marsh along with ducks, geese, and swans. They can be viewed from a bridge that has water fowl on either side, separated by a gate under the bridge. Graphics along the path describe the plants and trees in the exhibit. This is a Sand Hill crane and a chick foraging for food and plants as they would in the wild. (Emil Rossdeutscher.)

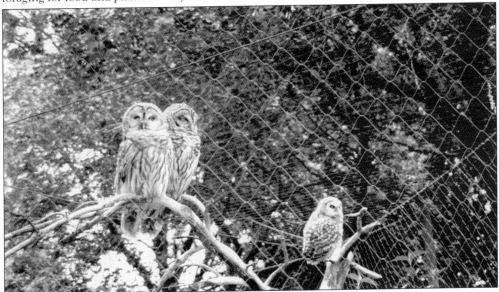

In addition to birds in the Aviary there are rescued birds that are native to North America. Two Bald Eagles named after the ex–Queens borough president and her husband are known as Claire and Mel. The barred owls pictured here are in a netted enclosure. They get their name from the brown bars that can be found along their abdomen and chest. (Joan Scheier.)

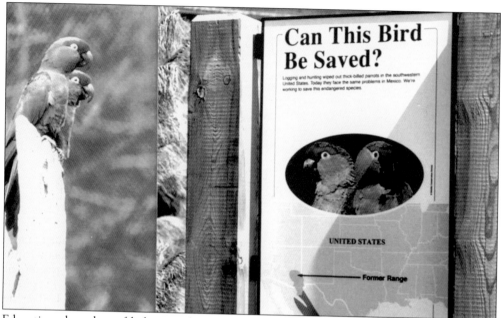

Education about loss of habitat and saving a species is the theme of this thick billed parrot exhibit. The graphic leading into the exhibit explains that the parrots, because of loss of habitat and over hunting, are becoming an endangered species. This is one way that the Queens Zoo and the Wildlife Conservation Society partner with a geographic area to save a species through education. (Emil Rossdeutscher.)

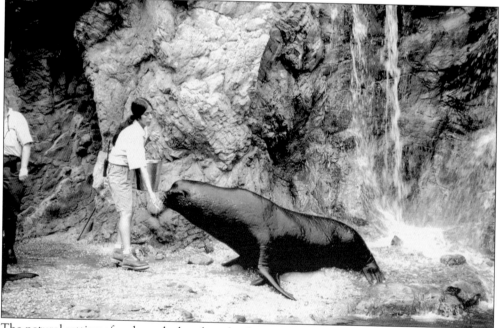

The natural setting of rocks and a beach make this an ideal exhibit for the large male sea lions. The sea lions have been trained to lie down at a command that allows keepers to get a close-up view and do hands-on examination. The fish also contain vitamins that help keep them healthy. (Joan Scheier.)

Six

NEW YORK AQUARIUM

The New York Aquarium is the oldest, continuously operating aquarium in the United States. Originally opened in 1896 in the famous Castle Clinton at Battery Park, at the southern tip of Manhattan, the aquarium served an average of over two million visitors each year. When the urban designer Robert Moses proposed building a bridge to connect lower Manhattan to Brooklyn, at the site of today's Brooklyn-Battery tunnel, the aquarium was moved in 1941 to the grounds of the Bronx Zoo. The aquarium opened at its present location on Coney Island, on June 6, 1957, on the site of Wonderland, the historic, world's-first theme park.

Today the aquarium serves about 800,000 visitors yearly. In its early years, attendance was lower due to Coney Island's distance from Manhattan's bustling tourism. However the current guest experiences a far richer array of exhibits and programs than those of 100 years earlier.

The aquarium now houses over 10,000 live, aquatic animals, including a pack of California sea otters, rare African cichlid fishes, some extinct in the wild, and walruses rescued as orphaned pups in Alaska.

In 1998, the aquarium spearheaded the founding of the Ocean Project, the largest collaboration ever formed to increase public awareness of the crucial role the oceans play in human survival. The aquarium has a long history of involvement in marine research, punctuated by William Beebe's historic dive into the deep sea with Otis Barton in 1934 when they plunged to a depth of over 3,000 feet, a record 10 times deeper than any had gone before. Through the 1970s and 1980s, aquarium scientists figured prominently in the search for "drugs from the sea," as they looked for molecules with beneficial biological effects. The aquarium's research continues today in another cutting-edge area of science, animal cognition, communication, and behavior. This program, home of the Center for Studies on the Evolution of Intelligence, is informing the creation of innovative new marine mammal exhibits.

The aquarium has embarked on a path to fulfill a master plan, re-inventing the institution in the midst of a rejuvenation of historic Coney Island. From angel fish to penguins, sea horses, jellyfish, and moray eels—America's oldest public aquarium continues to push the envelope of opening and interpreting the aquatic world to visitors of all ages.

—Dr. Paul J. Boyle, Director, New York Aquarium

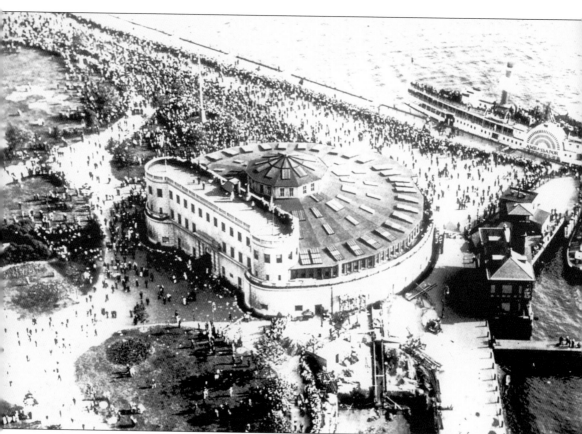

The site of the aquarium at Battery Park originally opened as a fort in 1807. It was located at the south end of Manhattan. The site was once used as a landing site for immigrants entering the United States. In 1823, the land was ceded to the city and used as a place of amusement called Castle Garden with a seating capacity of 6,000. The aquarium opened in 1896 and in 1902 became part of the New York Zoological Society. In September 1941, the aquarium closed and was housed at the Bronx Zoo before it moved to Coney Island, Brooklyn, New York. The permanent home of the new aquarium opened in 1957 welcoming once again sea lions, manatees, and exotic marine life. The New York Aquarium is the earliest founded aquarium in the United States. (© WCS.)

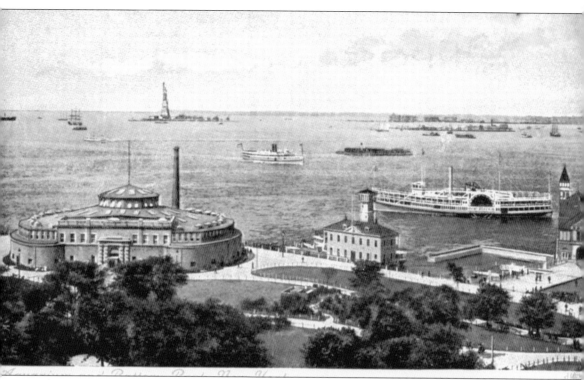

The New York Aquarium opened in 1896 under city management and was the largest aquarium in the world. It contained seven large pools, 94 wall tanks, and 25 smaller tanks. From 1897 to 1913, the average daily attendance was over 5,000 visitors a day. The aquarium was open every day and was free of charge. The Statue of Liberty can be seen in the background. The customs house and ferry landing were all close by. (Joan Scheier.)

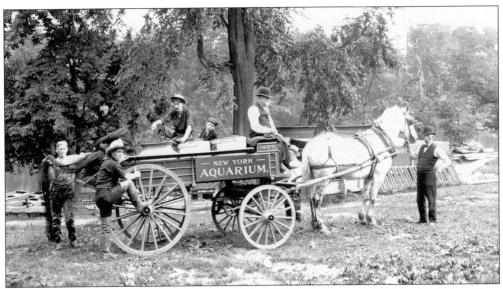

This photograph dated 1906 shows a group of fishermen in a wagon marked New York Aquarium carrying specimens that would be included in the collection or be used as food for the larger fish and marine mammals. The large drums in the wagon were used to keep the fish fresh and alive. (© WCS.)

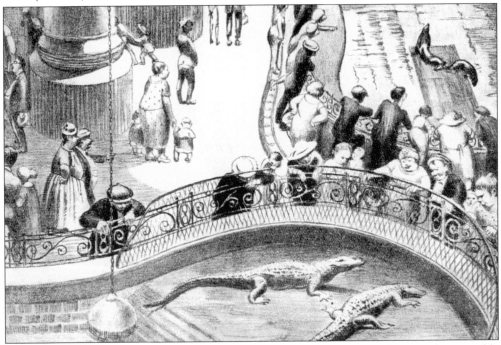

The drawing made in the early 1900s gives a view from the upper level, showing the crocodile and sea lion enclosures. The kidney-shaped tanks could be viewed from above and the side. The crocodile, alligator, and sea lion exhibits included steps so that the animals could climb to the top to rest above water, allowing visitors a better view. The railings were ornate wrought iron and the high domed ceiling let in light. The columns gave the exhibit the feeling of an indoor castle. (Private collection.)

How to care for Salt Water Aquarium. Sea Water and marine plants must be used with marine animals. Loss through evaporation may be replaced with fresh water from the faucet as most of the original salts remain. Water may be aerated by removing a little and allowing it to fall back from a height of several inches, or may be siphoned off from the bottom and used again after filtering through cheesecloth. The best plants are sea lettuce and red algae. Sea lettuce should be buoyed with bits of cork to cover most of the surface and allowed to hang down on the side nearest the light. Clean white sand or pebbles and a few stones should be placed on the bottom. Round glass aquaria are best and an 8-gallon jar most desirable. No direct sunlight should strike the aquarium in summer, little in winter. Northern white coral, two or three each of brown and white anemones, prawns and minnows, will thrive, with a small clam to clarify, and half dozen mud snails for scavengers. Very small crabs and mussels may be introduced, also barnacles and tube-dwelling worms. Four animals to the gallon are enough. Desirable food is chopped clams, mussels, dried shrimp, or dessicated codfish after soaking out the salt. Uneaten food should be siphoned off and dead animals and plants promptly removed.

This unique postcard from the aquarium gives detailed instructions on how to start and care for a salt water aquarium. Education about ocean life has always been a priority at the aquarium. Details on this postcard include the amount of light necessary, as well as details for cleaning, feeding, placing of specimens, and the amount of water needed for four specimens. The final sentence states that uneaten food should be siphoned off and dead animals and plants promptly removed. (Joan Scheier.)

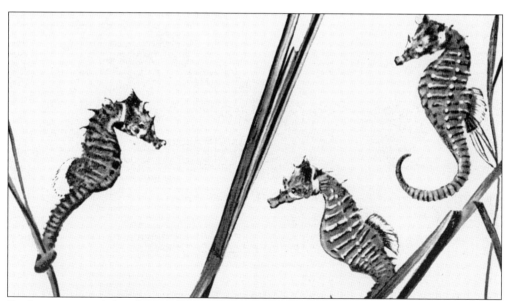

Sea horses were exhibited in smaller tanks on the balcony level. They have been at the aquarium from the beginning. It is one of the few fish that has a grasping tail and grows to be about seven inches tall. They have a long horse-like head, hence the name sea horse. (Joan Scheier.)

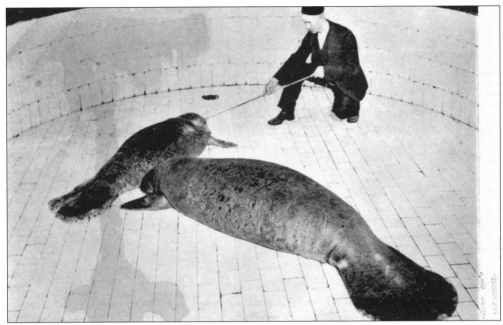

In 1906, one of the five large, tiled pools at the aquarium in 1906 contained two large manatees, also known as sea cows. Manatees are marine mammals that breathe air like we do. Manatees are an endangered species and the aquarium teaches conservation of these marine mammals whose only predator is man. (Joan Scheier.)

Lining the walls were smaller tanks standing in ornate wrought iron cases. The tanks would hold both salt and fresh water fish. This photograph was taken in 1941 shortly before the aquarium closed at this location. (© WCS.)

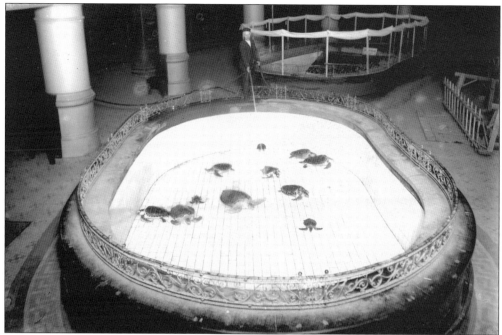

The balcony contained many exhibits located in tanks placed against the walls. The keepers would make the rounds daily cleaning and caring for the smaller tanks. In 1906, the view from the balcony overlooks the turtle pool and shows the keeper cleaning the enclosure. Tiles were used and were easy to drain, clean, and replace with clean water. (© WCS.)

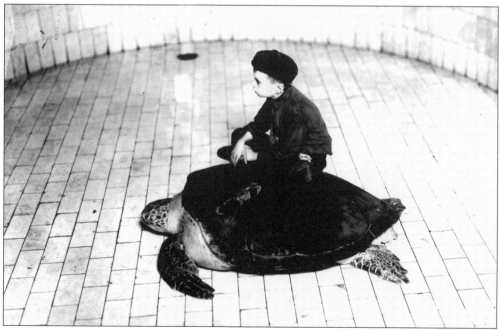

This photograph, also taken in 1906, is of the pool that contained the larger sea turtles. The water was let out through a drain in the rear. Children, when chosen, were allowed to take a ride on the back of these large turtles. The height of this tank was about four feet. (© WCS.)

Every fish in the New York Aquarium is having its portrait painted by Nikolai Gelikovsky, WPA artist. The artist's services were supplied by the WPA Art Service at the request of the aquarium officials and the New York Zoological Society. The title of this photograph is "Darting Tropical Fish Give Artists a Hard Task," dated December 6, 1935. WPA artists installed many mosaics, statues, and murals at the New York City Zoos during the 1930s. There are photographs of all the New York City Zoos taken by WPA photographers that can be located in museums, park, and photograph archives. (NYC Municipal Archives, WPA records.)

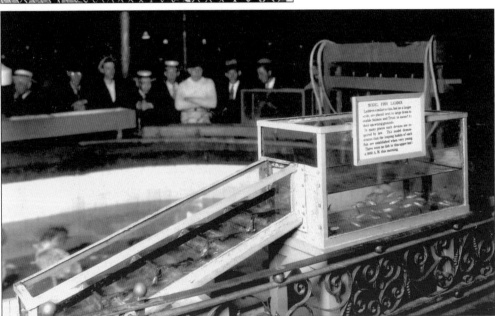

Scientific exhibits such as Fish Ladder would be used to illustrate the spawning behaviors of fish. The exhibit would be changed to include fish that would be spawning. It would be a continual exhibit to illustrate how salmon and trout would go upstream to reach their spawning grounds. This model demonstrates that the leaping behavior of such fish are established when they are very young. (© WCS.)

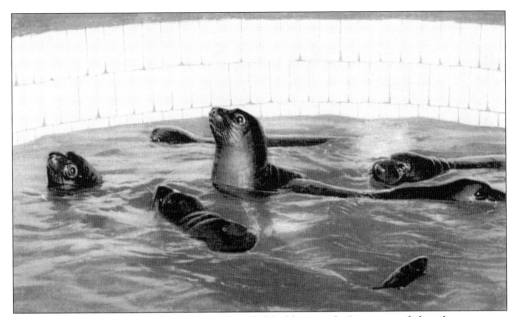

Large male sea lions occupied another of the tiled holding pools. It was stated that the water was the same color as the ocean that would have been their home. They would be fed eels, squid, and herring. At the other end the pool area were steps that the sea lions could climb and rest out of the water. (Joan Scheier.)

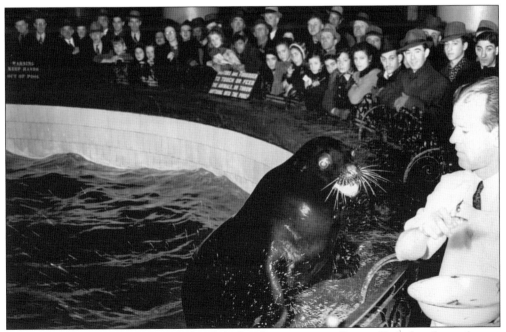

This photograph was taken in 1941 shortly before the aquarium at Battery Park closed to make way for the construction of the Brooklyn Battery Tunnel. Sea Lions are always up on their flippers at feeding time waiting to be hand fed, vitamins included. Sea lions did not return to the aquarium until 1957, after the aquarium had moved to its new home in Coney Island. (© WCS.)

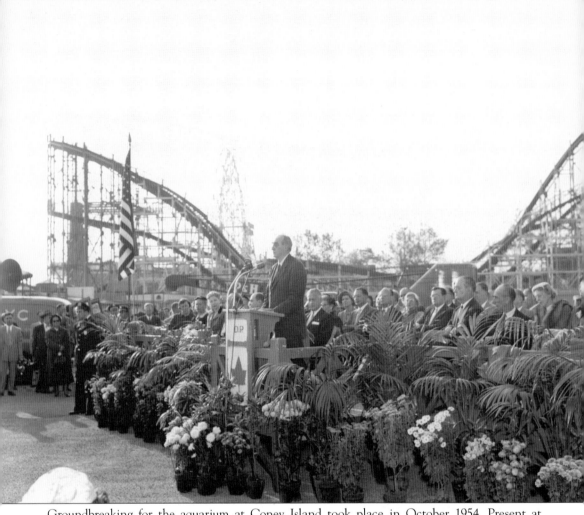

Groundbreaking for the aquarium at Coney Island took place in October 1954. Present at this event was Robert Moses, noted for his many building projects including zoos of New York City. The new aquarium would be located right off the Atlantic Ocean, steps away from the boardwalk. In the background is the world famous roller coaster known as the Cyclone. The aquarium would reopen with 14 acres of seaside property and more than 350 species of marine life. (© WCS.)

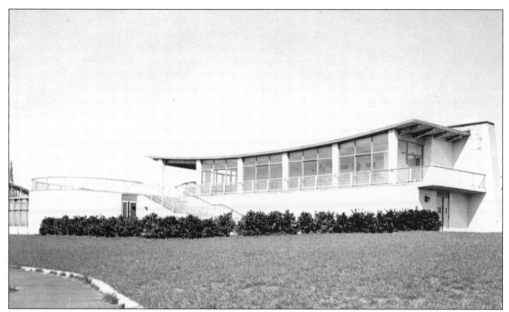

This postcard shows the first stage of the building of the aquarium. The cafeteria would be on a glassed-in level that would overlook the ocean. Fish tanks would line the walls of the first floor as you enter. With large glass underwater viewing, the front area would have outdoor pools for the seals and sea lions. The entrance to the aquarium would be on Surf Avenue and West Eighth Street, convenient to several subway and bus lines. (Joan Scheier.)

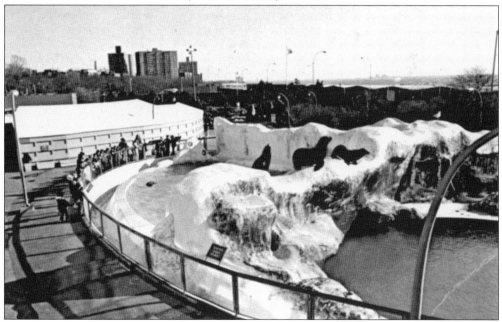

By 1979, the aquarium had three pools for harbor seals, fur seals, and sea lions. Barking was a familiar sound along the boardwalk at Coney Island. The cafeteria building that overlooked this area was renovated in the 1990s to make way for a new exhibit Sea Cliffs, which had underwater viewing panels. Today the sea lions appear in a large aqua theater that gives daily demonstrations with narration and audience participation. (Joan Scheier.)

In 1957, the aquarium opened at Coney Island, Brooklyn, New York. This photograph taken that year shows the use of a headphone to listen to tapes that told about the exhibits. This is one of the new innovations for that time. The emphasis today, as it was then, is on education. (© WCS.)

The electric eel exhibit was one of the most popular exhibits, and it drew large crowds of school children who visited the aquarium. There was an electric meter at the side of the exhibit that would measure the electrical currents of the eels. The eel can produce a 600 volt electric shock. With age, the amperage of the fish's electric shock increases. When the keeper fed the eels the electricity would rise. (© WCS.)

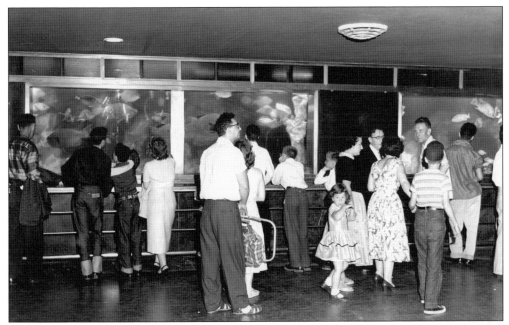

The aquarium was the logical place to learn about marine life from all over the world. The main exhibition hall had large windows for viewing exotic fish large and small. Exhibits also included local fresh water and salt water marine life. This was considered a state of the art aquarium in 1957 as it still is today with its ongoing educational programs and expanding exhibits. (© WCS.)

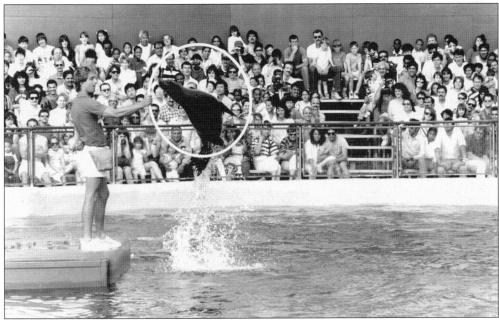

Sea lions have always been a favorite at four of the New York City Zoos and at the aquarium. A demonstration shows how high the sea lion can porpoise, in order to gain speed to go through the raised hoop. This is an example of the many educational demonstrations that occur during the day. A narrator will tell the audience about the special adaptations sea lions have made to the ocean and why this behavior is important to escape a predator or chase down their food. (© WCS.)

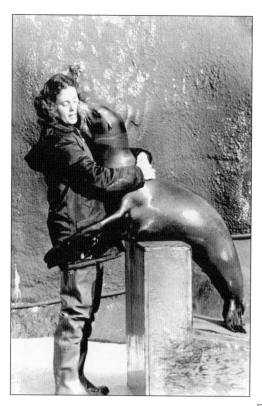

Here is Breezy, a sea lion with her trainer at the aquarium. Sea lions have very powerful front flippers which can hold their body weight of 300 pounds. Here she is using her flippers to give her keeper a hug. There is a great deal of trust and rapport with their keepers. Breezy now resides at the Central Park Zoo, in a smaller pool with rocks, a waterfall, and a beach. She is under the watchful eye of the same keeper from the aquarium in 1980. (Celia Ackerman.)

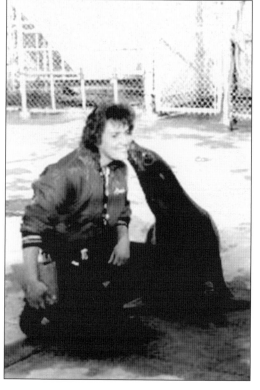

Seaweed's second home was at the aquarium. She now shares the beach at the Central Park Zoo with Breezy. They are considered senior sea lions, a testament to the advances in animal care. The keepers hand feed both sea lions and put them through their behaviors, which include barking and standing on their flippers as well as opening their mouths so that the keeper can examine their teeth and gums. Demonstrations of behaviors are meant to be fun for the audience but provide enrichment for the animals as well. (Ann Yaiullo, Atlantis Marineworld, Riverhead, New York.)

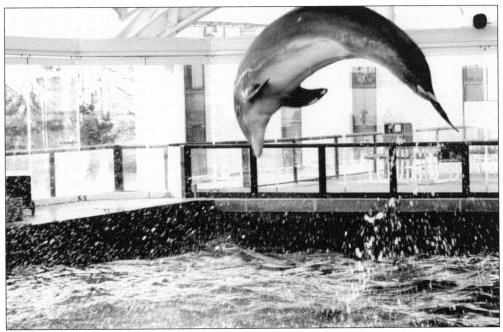

Oceanic was the first tank used for exhibits at the aquarium. It would be enclosed in the winter and open during the summer. Here is an example of dolphins' jumping ability. Dolphins have a long beaklike snout, sharp teeth, and a single blow hole located at the top of the head. A new aqua theater replaced this exhibit in the 1980s. (Emil Rossdeutscher.)

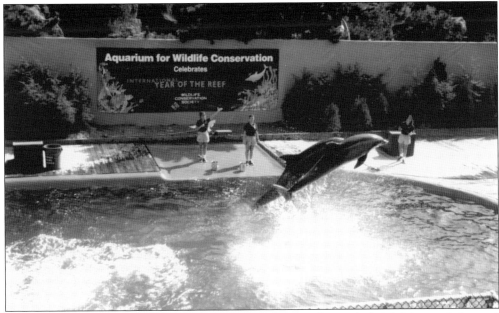

The aqua theater was enlarged to allow for demonstrations that included dolphins, whales, and sea lions. This photograph demonstrates a bottle-nosed dolphin jumping over 20 feet out of the water. The New York City Zoos and Aquarium are always moving forward by adding new exhibits as well as upgrading existing exhibits to increase the enjoyment of both visitors and animals. (Emil Rossdeutscher.)

There are many demonstrations given behind the scenes for small groups of adults and young people. Here a trainer is showing her group how she trains Otis to open his mouth at a certain hand command. This gives the public an idea about the patience that is involved in training these behaviors, which may look like fun, but the keepers use them as part of a health check that is done on a daily basis. The aquarium has a teenage docent program. Many of the keepers have begun their training as volunteers at the six facilities located in New York City. (Joan Scheier.)

Sea horses have been on exhibit at the aquarium since 1896. Here the sea horse can be easily seen against a bright red coral background. They are a type of small fish that have armored plates all over their body, not scales. They can change their color to hide themselves from their enemies. Females produce eggs, which are held inside the males' body until they hatch. The sea horse is the only fish in which the father can be said to be pregnant. (Emil Rossdeutscher.)

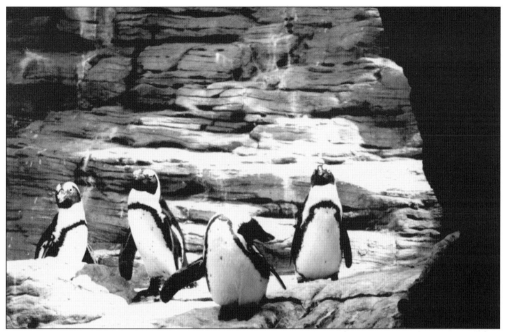

The blackfoot penguins are birds that cannot fly. The Sea Cliff outdoor exhibits are located in the Sea Cliff area. The man-made exhibit duplicates the environment they would find in the wild. There are man-made rocks for climbing and a pool for swimming and diving. They may be clumsy on land but are excellent swimmers. (Emil Rossdeutscher.)

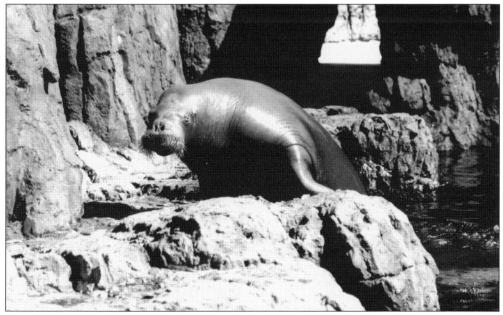

The walrus is a large noisy mammal that spends much of its life in the sea but always enjoys sunbathing on the beach. The walrus at the aquarium is comfortable in his naturalistic Sea Cliffs exhibit. The walrus can grow up to 14 feet in length and the males weigh up to 3,000 pounds. There are volunteers that are stationed at the exhibits to give information and answer questions. (Emil Rossdeutscher.)

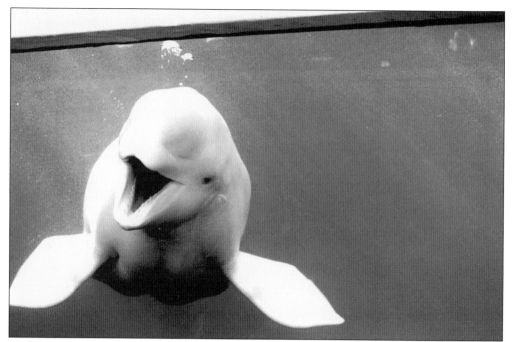

Underwater viewing windows give the visitors a close look at the Beluga whale and many other forms of marine life. It does appear that this Beluga whale is smiling at the visitors. The air can be seen exiting its blow hole, which is located at the top of its head. (Emil Rossdeutscher.)

NEW YORK AQUARIUM

The boardwalk at Coney Island is a colorful area of New York City. Astroland, the amusement park is just steps away from the aquarium as is Nathan's home of the hot dog. This colorful mosaic located along the Boardwalk depicts the many forms of marine life that can be found in the aquarium. The mission of the aquarium is to raise public awareness about issues facing the ocean and its inhabitants through special exhibits, public events, and research done at the aquarium's Osborn Laboratories of Marine Sciences. (Joan Scheier.)

Seven

CHILDREN'S ZOOS

I drove home from work the other day to find the driveway filled with shaving cream. Since it was not Halloween I was puzzled by this act of seemingly random mischief. After parking in the street I inspected the driveway and realized there were words like "column," "exceed," and "project," written in shaving cream. Clearly, these neighborhood hoodlums were sending a coded message I couldn't understand!

Later that evening I learned that my wife, who is a wonderful educator, was using my shaving cream to help our 8-year-old learn his spelling words! She had literally concretized the concept of making learning fun. While parents may be playing games for the schooling, children are absorbed by being entertained. In fact, anyone who has tried to separate a child from playing their video games quickly realizes the shrinking attention span of today's youth is really a myth.

Nowhere does the union of play and learning exemplify itself more than at a children's zoo. Concrete structures, made to look like natural habitats, are filled with nooks and crannies of education, discovery, entertainment, and wonder. As a child, growing up in New York, I remember the excitement of the next animal exhibit along the path. Always thinking, "Which animal is in the next one? What will the animals be doing? Are the keepers there for a feeding?" Typically last, but never least, there was the wonderful interaction in the petting area where I got to experience the joy of being licked by a goat. Going to the zoo with the family and interacting with the animals always creates a very special day with memories that really do last a lifetime.

But that which escapes you as a child comes out when you are an adult. It is the secret that you learned something while you were playing. Everything we learn about the animals helps us understand our planet, our social interactions, and ourselves.

So go ahead and take the kids to one of New York City's great zoos and be sure to stop by the children's zoos that have been part of the zoos since the 1940s. It will never be so easy to have some fun while your child learns. Unless of course you have some concrete, a can of shaving cream, and do not mind Daddy growing some stubble.

—Allen Esses

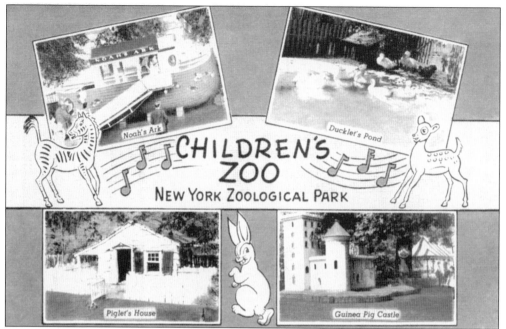

The earliest children's zoo opened at the Bronx Zoo in 1941. The theme was a combination of fairy tales coming to life and a small petting zoo. The children zoo today is located in a separate area of the main zoo. The animals in the exhibits are farm and domestic animals that the visitors can feed and touch all the while hearing the sounds that the animals make. Interactive exhibits, graphics, and zoo guides help to educate the young visitors about the care of the animals. (Joan Scheier.)

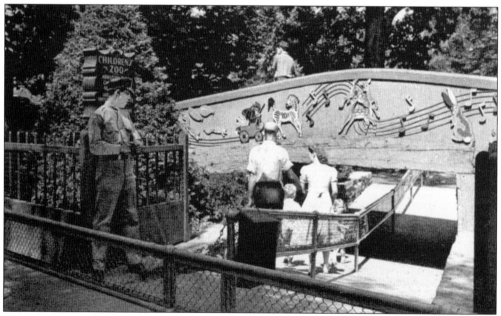

The entrance to the Bronx Children's zoo allowed the children to walk upright under the bridge, while grown-ups had to duck their heads. This added to the feeling that this zoo's main theme was about children. The front of the bridge was adorned with familiar animal figures. (Don Lewis.)

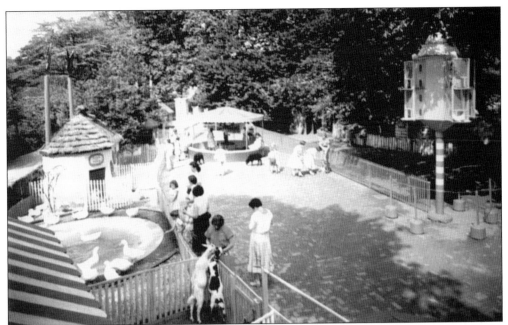

The sign stated that "Adults could not be admitted, unless accompanied by a child." The Children's zoo was in a separate section of the zoo where children could approach and learn about animals in a fairy tale setting. Everything in the Bronx Children's Zoo was scaled down to child size exhibits and small animals. (Joan Scheier.)

The wishing seat kept with the theme of children's fairy tales, where you make a wish and it comes true. You sat in the seat and made your wish. This is the author at the children's zoo on a family trip in 1945. (Joan Scheier.)

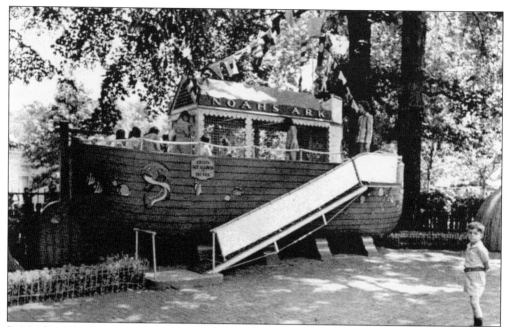

In Noah's Ark, the animals lived two by two. No grown-ups were allowed on the Ark. The idea of the children's zoo was to keep everything on a child's scale. It made the children feel like the exhibit was made just for them. (Don Lewis.)

Three little pigs, a rooster, and some kittens lived in this tumble down house that belonged to Piglet, a character from the A. A. Milnes classic *Winnie the Pooh*. The animals could be seen in the yard or perched on window sills. (Don Lewis.)

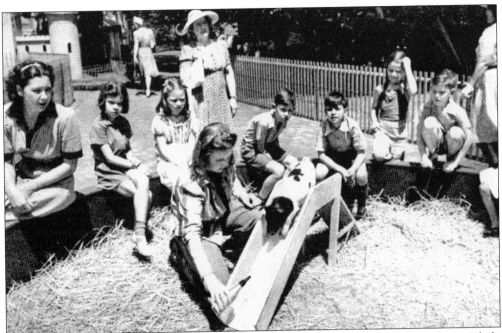

After a few trials, a piglet learned to use the slide for a reward of a drink of milk. The keepers help the children to learn about the animals and the behaviors they are learning. This is one of the few places in the city were a New York City child could touch, feel, and feed a piglet. (Don Lewis.)

A young girl and a small bird get a chance to get a close look at each other. The animals in the children's zoo were used to being among very young children. Keepers were available to keep an eye on both visitors and animals. (Don Lewis.)

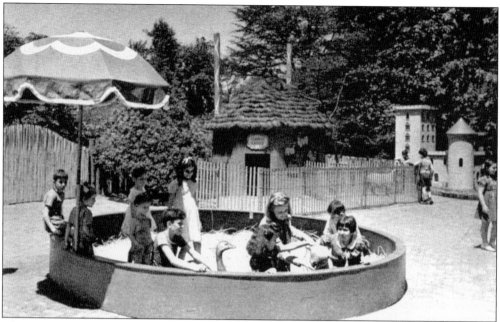

The small play ring was used to introduce children to small animals. The animals would be taken out of their house for short periods of time and brought into the ring. The animals would include ducks, piglets, and new chicks. (Don Lewis.)

Today the children's zoo is home to many farm animals. This shows two goats interacting with the public. This photograph indicates that not only youngsters can be tickled by what they see or feel. Keepers are in the area helping the visitors to feed the animals. The children's zoo engages kids through direct contact in a domestic area or petting zoo. They can also explore from an animal's perspective by crawling through a log like an otter, exploring a prairie dog tunnel, resting in a bird's nest, or climbing on a giant spider web. (Joanne Steinhardt.)

In 1961, the Central Park Zoo children's zoo was known as the Herbert Lehman's Children's Zoo. The theme was children's stories. The entrance is a sculpted gate by Paul Manship. The top of the gate is decorated with goats and Pan, a mythical figure that would lead children into the zoo. The two arches on either side of the gate are decorated with birds and young boys playing bagpipes. The buildings along Fifth Avenue can be seen behind the gates. (Joan Scheier.)

The children's zoo was a big attraction from the start. Many story book houses came to life along with a large fiberglass whale that came to be known as "Whale-y," who acted as the entrance into the children's zoo. The children's zoo included a merry-go-ground, a slide down a rabbit hole from Alice in Wonderland, a gingerbread house, and the brick house of the three little pigs. The children's zoo was located just up a path from the main zoo. The buildings along Fifth Avenue and Sixty-fifth Street can be seen in the background. (Joan Scheier.)

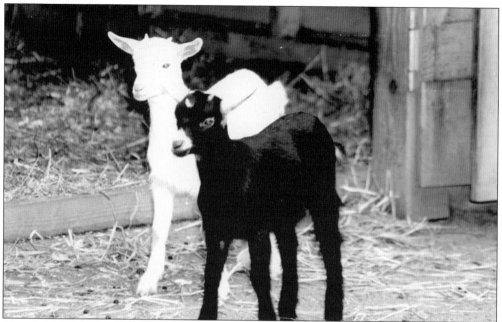

The children's zoo reopened in 1997 as the Tisch Children's Zoo, with the emphasis on farm animals and education. The keepers brush the animals and clean the enclosures while visitors watch. The keepers and volunteers will tell about the animals and there are many graphics placed next to the exhibits. Visitors can feed the goats, sheep, alpacas, and cows from food purchased at vending machines. (Ferne Spieler.)

Large fiberglass books located next to each animal have a rhyming graphic that tell about the animal. The largest animal is a cow named Othello. City children are often surprised by the size of the animals since they have only seen them in picture books. Petting and feeding the animals is encouraged. Hand-washing stations are all around the area. (Joan Scheier.)

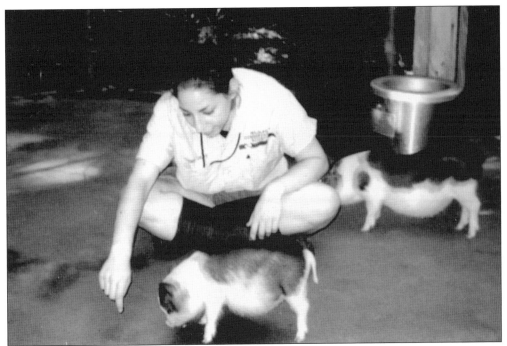

In addition to farm animals there are many species of birds, turtles, and frogs in an enclosed netted area with interactive exhibits such as a spider web for climbing and animals statues that, when touched, make the sounds of the animals in the enclosures. The newest additions to the children's zoo are two pot bellied pigs named Otis and Oliver. They are used to visitors coming over to greet them. They have behavior training where they are rewarded with food pellets. (Joan Scheier.)

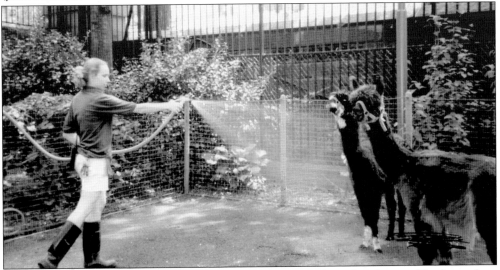

Two alpacas at the children's zoo are enjoying a cooling spray from their keeper. The fence along Fifth Avenue is a favorite viewing area for strollers along the avenue. An alpaca is a soft wooly mammal that is smaller than a llama or camel. Every spring the zoo sponsors a sheep shearing at the zoo and explains the many uses of the wool that was collected. The children's zoo is just up a path from the main zoo. (Joan Scheier.)

The Wildlife Theater performs at the zoos run by the Wildlife Conservation Society. The main stage theater is in the main area of the Central Park Zoo and the Acorn Theater is located in the children zoo. The performances, through the use of puppets and costumed characters and original songs, educate young visitors about the animals and environmental issues such as habitat loss and pollution. (Joan Scheier.)

Interactive exhibits include large eggs that children can crawl into and have an idea what it is like to be inside of an egg or enter a turtle shell with just their heads sticking out. Water lily pads located next to the frog and turtle exhibit allow the children to hop from one exhibit to another. Part of the children's zoo is netted so that birds such as pheasants, crested doves, magpies, and ducks are free to walk through the exhibit in safety. (Joan Scheier.)

The Prospect Park Zoo originally had a domestic farm animal area. Here is a cow enjoying the petting from a young girl. The petting zoo also included llamas, goats, sheep, and chickens. (© WCS.)

Large egg shells are part of the interactive exhibits used at the children's zoo. Here is a young boy getting the feeling of what it would be like to hatch out from an egg. (© WCS.)

The Prospect Park's Domestic Animal Area includes hands on experience for youngsters. Here plastic cows, complete with milking chairs allow the city youngsters to get the feeling of what it would be like to milk a cow. Other farm animals on the domestic side of the zoo include sheep, cows, roosters, and goats. (Joan Scheier.)

The Discovery Trail, located in the World of Animals area includes emus, turkeys, cranes, owls, rabbits, kangaroos, and wallaby's. The exhibit shown above invites the youngsters to see if they can jump as far as a flea (one foot), a rabbit (four feet), a bullfrog (nine feet), and a wallaby (12 feet). This jumping exhibit is a fun way to learn one of the differences in jumping distances between species. (Joan Scheier.)

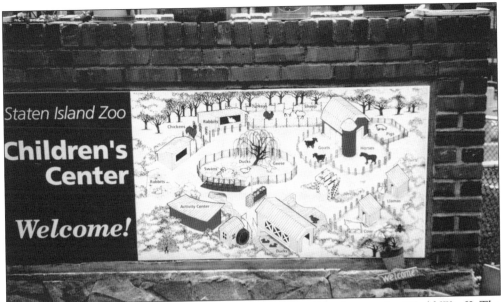

The idea of a permanent children's zoo at the Staten Island Zoo began after World War II. The idea became a reality in February 1970. It was re-named the Children's Center in 1974 with the emphasis on learning through fun. The layout is much like you would find on a farm. It includes a barn with goats, horses, and sheep. Rabbits live in realistic hutches and roosters perch on railings in their enclosures to greet the visitors. The entrance is through a covered bridge that separates it from the main zoo. (Joan Scheier.)

Part of a working farm would have been a vegetable garden. This small garden at the Children's Center is harvested and used to feed the animals. The scarecrow is included to keep away birds that are anxious to share the fruits of the garden. (Joan Scheier.)

Pony rides are part of the visit to the children's zoo. A keeper takes small visitors for a ride around the pony track for a small fee. The Shetland pony is the smallest breed of horse not over two feet tall. It has a gentle disposition and is therefore a favorite mount for children. (Joan Scheier.)

Farm animals are at all the New York City Zoos. Here are two pygmy goats with their keepers when they first arrived at the Staten Island Zoo. They are affectionate, cute, lovable, and playful. A full grown pygmy goat usually is less than two feet tall. This is a perfect size for children to pet. (Staten Island Zoo.)

Chicks and ducks and geese are all on view at the Queens Children's Domestic Area, along with roosters, chickens, pigs, cows, horses, llamas, and sheep. Here the ducks get close to the fencing hoping the children will provide them with food pellets. There are annual events such as sheep shearing in the spring, face painting at Halloween, and Bison Bonanza and gifts for the animals at Christmas. (Queens Borough Public, Library, LID illus.)

Feeding the animals is all part of the fun at the Children's Domestic Area of the Queens Zoo. Keepers and docents are there to explain about the animals and their nutrition. The children are also shown the correct way to approach an animal to pet it. (Queens Zoo.)

Queens Zoo visitors are delighted with the newest additions to the Domestic Area, two Nubian goat kids, named Simon and Garfunkel, in recognition of two famous former residents of Queens, Art Garfunkel and Paul Simon. With their long ears and sweet faces, the goats have become a favorite to the visitors. (© WCS.)

The aquarium has no specific children's areas but it does have many interactive exhibits such as a touch pool that contains horseshoe crabs, starfish, and other aquatic animals, an exhibit that allows you to compare your electric energy with that of an electric eel, and a plastic shark that shows the size of the teeth. Visitors can put their eyes through modified viewers to get a fish eye view. Aquatic voices allow visitors to hear the noise that fish can make. There is an enclosure that, with a touch of knob, you can change the direction of the current in the tank and watch the fish turn and follow the current. Here a young visitor is examining the tusks of a plastic, life-sized walrus. (Joan Scheier.)